WATERCOLOR ESSENTIALS

watercolor
ESSENTIALS

NORTH LIGHT BOOKS
CINCINNATI, OHIO
www.artistsnetwork.com

hands-on techniques for **exploring watercolor in motion**

birgit O'CONNOR

Other fine North Light Books are available from your local bookstore or art supply store. Also visit our website at www.fwmedia.com.

13 12 11 10 09 5 4 3 2 1

Distributed in Canada by Fraser Direct
100 Armstrong Avenue
Georgetown, ON, Canada L7G 5S4
Tel: (905) 877-4411

Distributed in the U.K. and Europe by David & Charles
Brunel House, Newton Abbot, Devon, TQ12 4PU, England
Tel: (+44) 1626 323200, Fax: (+44) 1626 323319
Email: postmaster@davidandcharles.co.uk

Distributed in Australia by Capricorn Link
P.O. Box 704, S. Windsor NSW, 2756 Australia
Tel: (02) 4577-3555

Library of Congress Cataloging in Publication Data
O'Connor, Birgit.
 Watercolor essentials : hands-on techniques for exploring watercolor in motion / by Birgit O'Connor. -- 1st ed.
 p. cm.
 Includes index.
 ISBN 978-1-60061-094-3 (hc : alk. paper)
 1. Watercolor painting--Technique. I. Title.
 ND2420.0272 2009
 751.42'2--dc22 2008036576

Edited by **Mary Burzlaff**
Designed by **Jennifer Hoffman**
Production coordinated by **Matt Wagner**

Metric Conversion Chart

TO CONVERT	TO	MULTIPLY BY
Inches	Centimeters	2.54
Centimeters	Inches	0.4
Feet	Centimeters	30.5
Centimeters	Feet	0.03
Yards	Meters	0.9
Meters	Yards	1.1

About the Author

Birgit O'Connor is a self-taught painter who has been painting strictly with watercolor since 1988. She resides in northern California where she has been teaching watercolor since 1998. She has written for several magazines, including *Watercolor Artist, The Artist's Magazine* and *Artist's Sketchbook*; and has produced thirteen instructional DVDs on watercolor instruction. She has exhibited her work in dozens of one-woman shows and group shows. Her work has won numerous awards and can be found in private and corporate collections around the globe as well as in galleries. Her website, **www.birgitoconnor.com**, features her DVDs, workshops and other materials for watercolorists. She is the author of *Watercolor in Motion* (North Light Books).

photo by Diane Ornoski

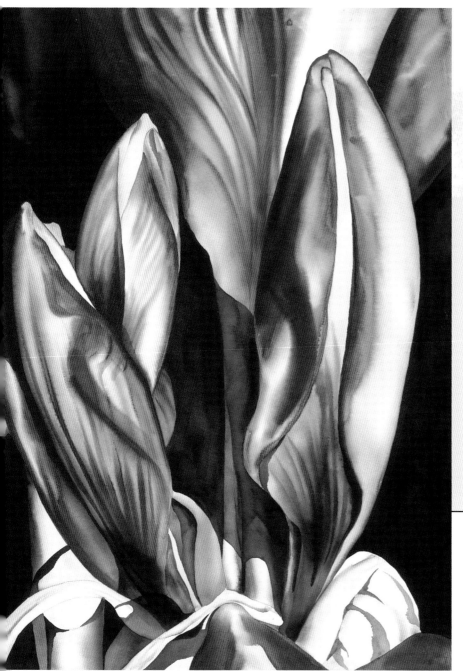

Dedication

To my family: Dan, Jim, Nick, Mom, Dad, Alison, Layla and Kiley **with love.**

before the bloom
watercolor on 300-lb. (640gsm) cold-pressed paper | 40" × 30" (102cm × 76cm)

Acknowledgments

Many thanks to Patricia Martin Osborne, Nancy Collins, Dan Heller and Ingrid Butler of Moth Marblers.

CONTENTS

MATERIALS 10

COLOR 24

VALUE 40

■ Follow along in the DVD to learn more about this subject.

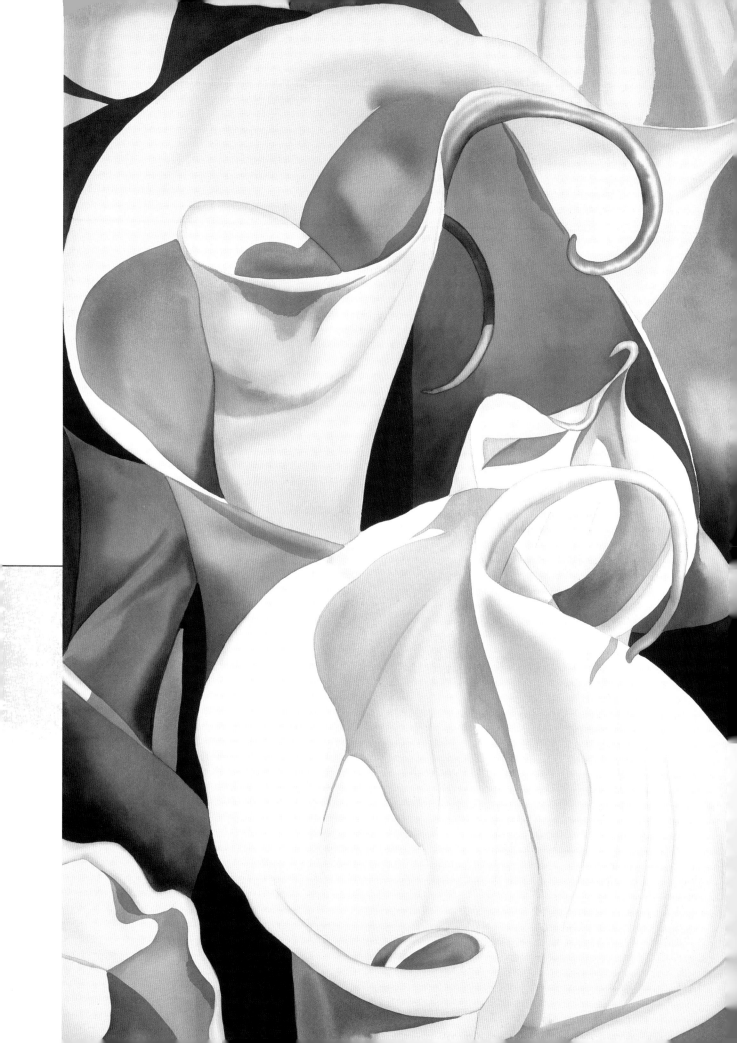

As a beginning watercolor artist, you may feel the need to try to exactly replicate the object you see. This may feel more natural, but if this is your goal you may become frustrated with the medium. You may try to draw more than actually paint, which can result in an overworked, labored and dry appearance, which is not at all what a watercolor painting should be.

The key is to relax, simplify and capture the essence of what you are seeing, not every little detail. Many people feel as if watercolor is uncontrollable; they might be a little afraid of the lack of control. Instead, sit back, have fun and play with the movement of the watercolor. The harder you try, the harder it is. Try to think of watercolor painting much like life and go with the flow.

INTRODUCTION

double calla
watercolor on 300-lb. (640gsm) cold-pressed paper | 60" × 40" (152cm × 102cm)

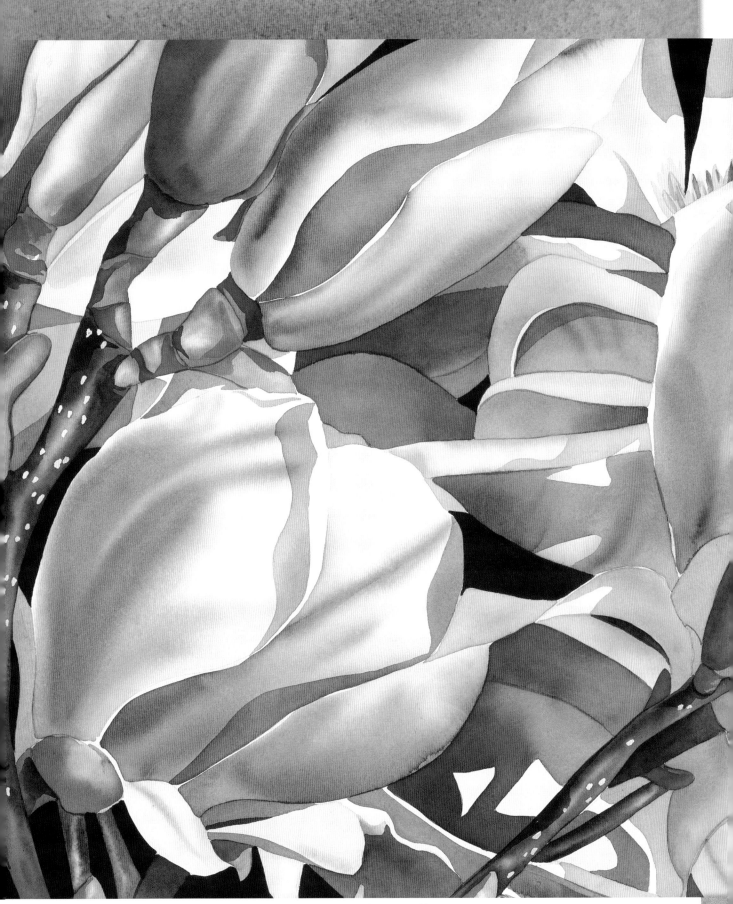

moments | watercolor on 140-lb. (300gsm) cold-pressed paper | 25" × 40" (64cm × 102cm)

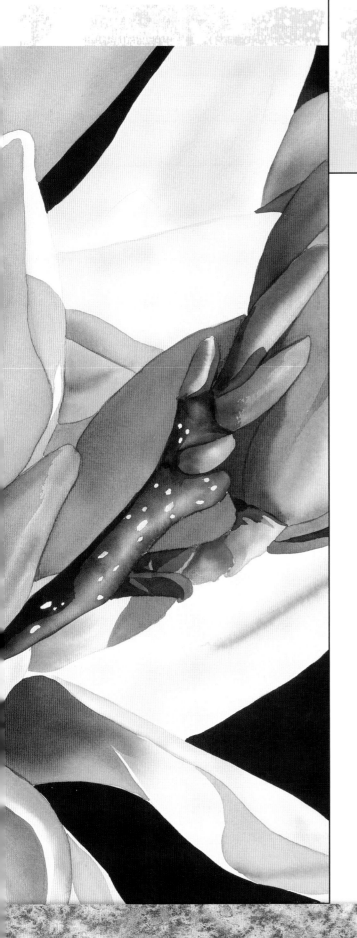

materials

Each watercolor artist has a slightly different approach, so experiment to find what you like and develop your own style. The materials you use are an important component to a successful watercolor painting. Learn what materials you really need (rather than thinking you need to purchase everything). Knowing the aspects of the various products and how to use them will make all the difference in the world.

Some people think that in order to be a good artist you have to attend art school or workshops and go to every art opening. This doesn't work for everyone's lifestyle, and this is not what determines your ability as an artist. Being a stay-at-home mom, I never had the time or the desire to do all of that, so I decided to teach myself to paint.

How do you teach yourself? For me, learning is a visual experience rather than an academic exercise. You need to know some basics, such as creating a wash, applying a glaze and keeping whites white. I learned the most from visual aids such as the step-by-step demonstrations in books and TV programs. Maybe this could work for you as well.

Painting with watercolor is really quite simple. You just have to think backwards—instead of applying lights over darks, save your whites and gradually build into your darker colors. Once you learn basic techniques you'll be able to look at other artists' works and figure out how they approach the painting process.

paint

Watercolor is available in different grades and a variety of forms. Experiment to find out what you like and what works in your paintings.

CAKES, PANS, BOTTLES AND TUBES

Cakes of color | These usually have very little glycerin, so the color appears concentrated. Since they are so dry they can be difficult to use. If you do use this type of paint, soften it by adding water to each color before you begin.

Pans | These are similar to cakes but have more glycerin, making them semimoist and easier to use. Available in full, half and quarter pans, they are compact, easy to use when sketching outdoors and convenient for travel.

Concentrated color in bottles | These highly concentrated colors are striking and it can be interesting to try them. However, since these liquid colors are so strong, a little can go a long way. Also, these paints aren't usually lightfast and can fade over time.

Tube colors | My personal favorite, these colors have a moist, creamy texture that blends beautifully when mixed on the palette or on paper. These are easier to use for washes covering large areas.

GOUACHE

Chalky in substance and opaque, gouache can be used more like acrylic paint. You can cover many mistakes and layer some of the lighter colors on top of darks. Gouache cannot achieve the same luminous glazing that is possible with transparent watercolor. These colors can easily mix into mud.

PROFESSIONAL VS. STUDENT GRADE

Larger professional-grade tubes save you time and money because they have less filler and more color.

Student-grade paints have less color and more filler, so they have weaker tinting strength and tend to fade, and some brands can be chalky.

TOXICITY

Watercolors are much less toxic than many other mediums, and manufacturers are continually working on improving and producing nontoxic substitutes. However, cobalts, cadmiums and other lead-based paints are still common. When using these colors, find a way to dispose of your dirty water so as not to endanger waterways. You may want to consider avoiding these pigments all together.

Pigment Possibilities

Watercolor is available in different grades and a variety of forms such as pans, half pans, cakes, tubes and concentrated color in bottles. Tube size ranges vary by manufacturer. Pay attention to price, size and quality when purchasing paints.

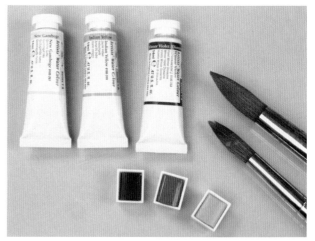

Tube and Pan Colors

Tube colors have a consistent creamy texture. Pan colors are harder and smaller, which makes it difficult to use large brushes without contaminating other colors.

BRAND DIFFERENCES

Each manufacturer's color blend is slightly different even if it has the same name. For example, some indigos might have more blue, black or even purple. Quinacridone Gold can range from a light yellow-gold to brown-gold to green-gold. Student- and professional-grade colors made by the same manufacturer can vary as well.

ORGANIZATION AND STORAGE

If you just love to buy art supplies and have lots of different colors, you might consider organizing and separating your tubes by color.

Small clear plastic craft boxes and tackle boxes usually have lots of compartments that are just the right size for paint tubes. You can designate sections for specific colors. Clear boxes work well since you can see the range of color inside without opening it, making them convenient for stacking. Plastic baggies, which are flexible and easy to use, are another inexpensive option.

Basic Palette

I MAY ADD COLORS FOR A SPECIFIC PAINTING, BUT THESE ARE COLORS I ALWAYS USE:

Burnt Sienna
French Ultramarine Blue
Burnt Umber
Cobalt Blue
Yellow Ochre
Indigo
New Gamboge
Quinacridone Gold
Sap Green or Viridian
Quinacridone Magenta
Hansa Yellow
Permanent Alizarin Crimson
Permanent Carmine
Winsor Violet

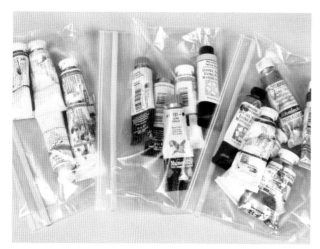

Storage Solutions—Baggies

Clear storage bags are an inexpensive and easy way to keep your paints separated by color.

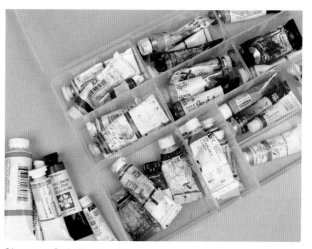

Storage Solutions—Boxes

Clear, sturdy craft boxes are available at many craft, art and sporting good stores. Tubes can easily be separated by color into compartments. The hard case makes it easy to stack and convenient for traveling.

palettes

Make sure that you have a large enough palette with a large mixing surface so that you have room to mix a couple of different combinations at a time.

SETTING UP THE PALETTE

There are several ways to set up your palette. You can arrange your colors in groupings of lights and darks or warm and cool colors or you can create a color wheel so that complementary colors are opposite each other or make your palette look like a rainbow. Choose what-ever makes the most sense and works for you.

FILLING THE PALETTE

Some artists like to fill the wells of their palettes with entire tubes of paint, allowing the paint to dry, then rewetting it when it's time to paint. To keep the colors damp, place a moist cloth or sponge in the center of the covered pal-ette or cover it with a sheet of plastic wrap. However, if you don't paint very often and leave your color this way, some paints can grow mold.

I prefer to squeeze out the amount of paint I think I will use. If some paint is left over, I leave it in my palette. Then, the next time I work, I add more paint to it until it has the creamy consistency and texture of new color. I find this method provides me with paint that flows, moves and allows me better coverage.

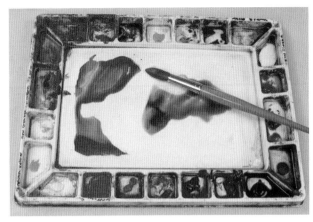

Select a Palette

Large, plastic-covered palettes work very well. They're light for traveling and inexpensive enough that you can keep several palettes with a variety of colors for different subjects. I prefer medium-depth flat wells. Water tends to accumulate in the bottom of deeper wells, making the color too diluted.

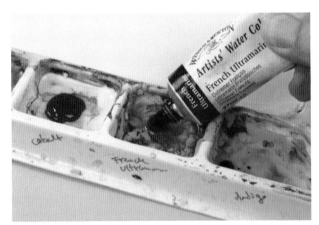

Label Colors

To help you learn the names of colors and keep track of what you are using, write the name of the color along the side with a permanent marker or on a piece of artist tape. You can remove the ink with nail polish remover, or you can just apply a new piece of tape.

Add Just a Dab

I like to add new color to the wells when painting. A large pea-sized squirt is usually enough. I prefer the texture of fresh paint for my washes and color blending.

brushes

Watercolor brushes can be expensive, but high quality brushes are well worth the investment. A few good brushes can last almost a lifetime if you take care of them.

Inexpensive brushes from sets or brushes not intended for watercolor usually are too soft or too hard as well as too small, and they do not hold enough water.

Expensive watercolor brushes do not guarantee a masterpiece, however. More important factors are the hair or fiber of the brush head, the kind of point, and the appropriate size for the type of painting you want to create. If possible, test the brush with clean water to get the feel of it before purchasing it. Many art stores allow you to do this to compare brushes.

The most commonly used brushes for artists are nos. 6, 8 and 10 rounds. These are fine for small paintings (no larger than 11" × 14" [28cm × 36cm]) and for detailed work, realistic paintings and botanical illustrations. For larger paintings, using small brushes can result in too many brushstrokes and an overworked and dry painting. As you increase the size of your painting, increase the size of your brushes. Unless you want tight work, consider using nos. 8, 14, 20 and 30. Many art stores carry only the smaller sizes, but they may order the larger ones for you. Or you can buy them online or through mail-order companies, or check my website for more information.

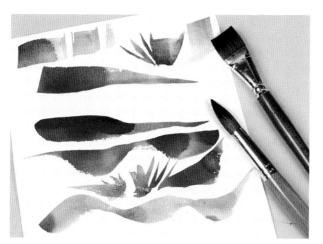

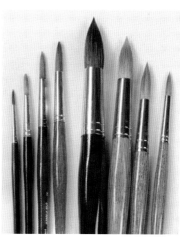

Brush Size Matters
See the difference between brushes that most artists use (nos. 3, 6, 8 and 10 on the left) and the ones that I prefer (nos. 30, 20, 14 and 8 on the right).

Different Brush Types
The type of brush and the amount of pressure you apply to the tip can change the entire look of a painting.

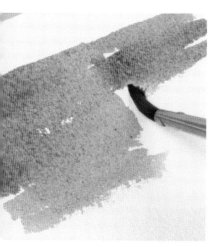

Small Brush Woes
A smaller brush runs out of color quickly, making it difficult to finish working an area before it dries. Using small brushes can create areas that look overworked and dry.

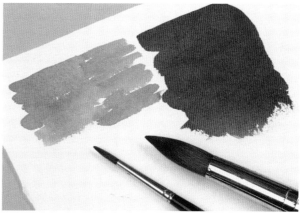

Brush Comparison
Notice how a no. 20 round covers a larger area with just a few strokes, creating better coverage and smoother color.

Smaller brushes may make you feel as if you have more control, but they often produce paintings that appear tight, labored, lifeless and dry.

brush fibers

Different brush fibers produce different results. Blends and synthetics work well for more controlled paintings, while natural brushes hold more water and color, and are softer, creating looser paintings.

NATURAL HAIR

Natural hair brushes hold the most water and are soft enough to easily layer color upon color without lifting previous layers. Among the different types of natural hair available are camel, skunk, ox, goat, squirrel and kolinsky sable. Pricing depends on the type of hair used.

SYNTHETIC

Synthetic brushes spring back to form quickly and hold much less water than blended or natural-hair brushes. Some higher quality synthetic brushes are almost comparable to sable/synthetic blends. Since they hold less water, the color holds together better with less dissipation. These brushes are ideal for creating veins or applying a bend or a fold within a flower, but they have a tendency to leave brushmarks in washes.

SABLE/SYNTHETIC BLEND

This brush is a good choice for most techniques. Sable/synthetic blends are a nice balance between natural hair and high quality synthetics. They can hold ample amounts of water and are soft enough to layer without lifting, and they still have the spring and control of a synthetic.

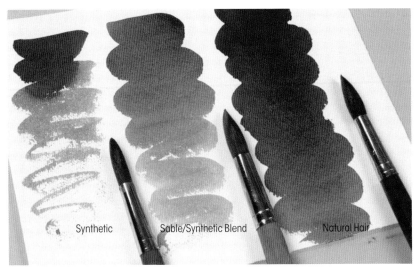

Synthetic Sable/Synthetic Blend Natural Hair

Water Retention Comparison

The synthetic brush (left) holds the least water and runs out of color the quickest. The sable/synthetic blend (middle) is a nice balance, holding more than the synthetic but not as much as a natural brush. The natural-hair brush (right) holds the most water, making the color application almost effortless.

Natural vs. Blend

The top brushstroke was created with a natural brush that skipped across the tooth of the paper. The bottom stroke was created by a combination blend. See how the additional synthetic hair helped give the stroke a cleaner edge. It is firm enough to apply deliberate color.

brush shapes

These are some of the most common brush types.

Round brushes are very versatile. Their brushstrokes range from wide and rounded to thin and delicate. Rounds create a soft, organic feel.

Flat brushes are angular and stiff. They create a deliberate, hard-edged appearance. Flats are good for both wide and thin strokes.

Filbert brushes are flat with a rounded point. They are useful for blending edges.

Cat's tongue brushes are filbert-style brushes with a tip.

Fan brushes have spread-out bristles in a fan shape. They work well for painting foliage and grass. When the brush gets wet, the hairs clump together, producing random strokes.

Detail brushes have tips that are short, pointed and precise. They are good for very tight details or retouching.

Line or liner brushes have long thin tips and are good for detail lines, fence lines and ropes.

Sword/dagger brushes create interesting brush-strokes, ranging from wide to very thin. They work well for painting fence lines and ropes.

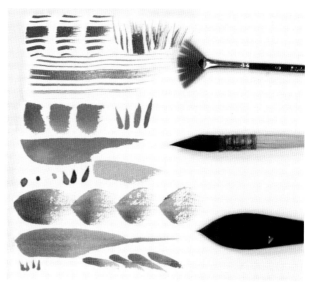

Different Strokes

Here are some of the interesting strokes you can create with fan, mop and cat's tongue brushes (top to bottom).

Note

Don't expect flat and round brushes to produce the same results.

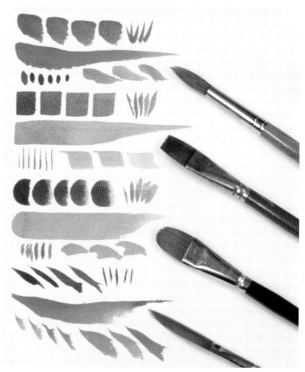

Brushstroke Possibilities

Here are some of the brushstrokes you can create with round, flat, filbert and sword brushes (top to bottom).

If you take care of your brushes, they can last a long time. Here are some dos and don'ts that will extend the life of your brushes.

First and foremost, never leave your brushes tip down in a jar or water container, even if only for a few moments. This can permanently damage the tip.

Instead, keep an old terry towel next to your container. Clean off your brush, then place it on the towel. The towel is absorbent and prevents the brushes from rolling around. Here are a few more rules to keep in mind:

- Dip your brush in water before you begin to prepare the tip.

- Dip your brush in water before dipping it into paint.

- Avoid submerging the entire tip in paint. Keep the color out near the point, not by the ferrule.

- Use watercolor brushes for watercolor only.

- Use only old inexpensive brushes for masking fluid.

CLEANING BRUSHES

Always rinse your brush thoroughly with clean, tepid water. If you feel soap is necessary or you have a staining pigment that you are trying to remove, use baby shampoo, liquid soap or brush soap. Gently work a lather in your hand and then into the tip. Rinse thoroughly and quickly flick the tip of the brush to remove the excess water (make sure there aren't any paintings nearby!) and reshape the tip.

STORING BRUSHES

If you can, store dry brushes vertically. A brush box or a bamboo brush roll is a good alternative for long periods of time or if space is an issue. This allows ventilation and protection of the hair.

HOLDING A BRUSH

Avoid holding your brush like a pencil. Instead, hold it a bit higher up the handle so that it's a little looser in your hand. You want a nice balancing point where it is comfortable but you still have control. The only time to hold a brush closer to the tip is when working on tighter details.

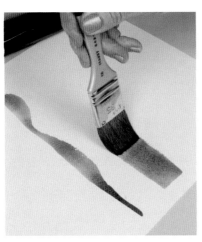

Brush Pressure

The amount of pressure you apply and the way you hold your brush will affect the stroke. When working in rounded areas, such as flowers, use round brushes. Flat brushes will produce a boxier, more angular look.

How to Hold a Brush

Find your balancing point so that the brush feels natural in your hand. Only hold your brush like a pencil when working on details.

Prevent Brush Damage

Do not leave your brush tip down in a container, or you can permanently damage the tip.

recommended brushes

These are the types of brushes you'll need for the exercises in this book. Try out many different brands to find your own favorite brushes. Here I'll explain the characteristics of my favorites and which work well for the techniques we'll be using. You don't have to use these exact brands. Feel free to experiment. Just try to find brushes that are comparable in size and fiber to those described here.

1 3-Inch (8cm) Bamboo Hake | This inexpensive brush holds lots of water, allowing great flow of color. However, its hairs fall out easily, which can create problems in large washes.

2 Nos. 8, 14 and 20 Sable/Synthetic Blend Rounds | The Da Vinci Cosmotop Mix F brushes have both natural hair and synthetic fiber. The natural hair holds a large amount of water, and the high-quality synthetic fibers give the brush tip more spring and control. This is a good all-around brush for many different techniques. It is soft enough to apply layer upon layer without lifting. These brushes can be difficult to find. Ask your local art store to order them for you. For more information, please visit my website at www.birgitoconnor.com.

3 Large, Natural-Hair Round | The Da Vinci Cosmotop Mix B no. 30 is a combination of several natural hairs. It holds more water than synthetic or blend brushes, so it is an excellent choice for wash techniques.

4 Nos. 8 and 20 Synthetic Rounds | The Da Vinci Cosmotop Spin synthetic rounds are high-quality brushes that are perfect for details or adding bends and folds.

5 No. 3 Synthetic Round | The Nova no. 3 is an inexpensive student-grade brush. Its stiff tip works well for lifting loose hair from a wash or for adding delicate veins to flowers.

6 Synthetic Wash Brush | The no. 60 Da Vinci Cosmotop wash mottler is a convenient size and applies an even layer of water.

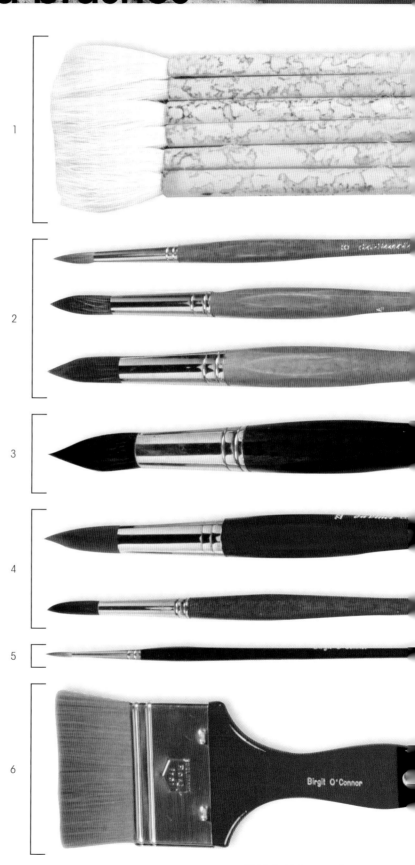

paper

There is a wide variety of fine art paper available, so deciding which one to use can be confusing. Each paper reacts differently. The fiber, sizing, weight and format all affect the way paper accepts water and color. These factors also affect the durability of the surface and the way it handles lifting and reworking.

To help you achieve the best results, here is some important information to keep in mind when you purchase paper.

FIBER

The fiber of the plants used for papermaking vary in length.

Cotton paper is the highest and most archival grade available. Often referred to as 100-percent rag, cotton paper is naturally acid free. Cotton has the longest and strongest fibers, making it the most durable for reworking and lifting.

Cellulose paper is low- to mid-quality student-grade paper and has the shortest fibers. Newsprint and construction paper are both made from cellulose. Cellulose papers are more acidic and are not archival. Over time, they can disintegrate.

Combination paper is a mixture of wood and cotton fiber. It is generally considered a multipurpose paper. Bristol board and many pastel, charcoal and watercolor papers are combination papers.

Paper Definitions

tooth	surface texture
ream	500 sheets of paper
gsm	grams per square meter
sizing	starchy glue that binds and strengthens paper

PAPER FINISH	HOW IT'S MADE	SURFACE	WORKING CHARACTERISTICS
Hot Press	Sheet dries in the mold, then is run through heated rollers to iron out the texture.	Smooth, hard, not very absorbent.	Controlled washes are difficult to achieve. Ideal where more dry-brush techniques are used (as in botanical illustrations). Works well for loose paintings where backruns and blossoming can be used to your advantage.
Cold Press	Sheet is removed from mold when not quite dry, then pressed without heat.	Semismooth, absorbent.	Absorbs water and color well and is easily workable. It is the most commonly used surface for watercolor.
Rough	Sheet is allowed to air-dry in the mold without any smoothing or pressing.	Very rough, absorbent.	Color skips across the rough surface and settles in the hollows, creating interesting effects. Wonderful for bold work or subjects for which texture is an advantage, such as fences, wood, barns or rocks. Not recommended for finely detailed paintings.

PAPER WEIGHT

The higher the number, the thicker and stiffer the paper is. Lighter weight papers such as a 90-lb. (190gsm) or 140-lb. (300gsm) tend to buckle more and accept less water and handling. Heavier papers such as 300-lb. (640gsm) are able to accept more water, lifting, reworking and general handling. Standard watercolor paper weights include 90-lb. (190gsm), 140-lb. (300gsm) and 300-lb. (640gsm), with some new additions now available in 260-lb. (550gsm) and 400-lb. (840gsm) weights.

FORMAT

Blocks are pads of mold-made, 100-percent cotton paper with sealed adhesive edges. It comes in a variety of sizes and eliminates the need for stretching. Blocks are wonderful for traveling or working in the field—you can grab your paper and off you go. To separate the paper from the block, insert a palette knife in the small entry point along the side, then follow the seam along the edge.

 Sheets are available in various sizes. A standard full sheet is 22" × 30" (56cm × 76cm), a single elephant is 25¾" × 40" (65cm × 102cm), a double elephant is 30" × 40" (76cm × 102cm) and a triple elephant is 40" × 60" (102cm × 152cm).

 Ten-yard (9m) rolls of 44½-inch (113cm) paper are a very economical way to purchase paper. You can cut any length you want, but the rolls can be difficult to use and store. To remove the memory of the curl,

cut your paper to the desired length, soak it in a tub, then hang it on a line with clothespins or mount it to a board with staples.

SIZING

Sizing is a glaze applied to paper to make it more resistant to moisture absorption. Paper with both internal and external sizing is best. External sizing creates a less absorbent, harder surface, allowing for richer color saturation. It is also more durable for reworking, lifting and scrubbing. Paper with only internal sizing tends to be soft, making it difficult to achieve rich, dark color saturation.

DECKLED EDGES

After the pulp is poured into the mold, the wooden frame resting on top defines the edges. It thins the pulp as it moves towards the outside, giving it a feathered appearance, which is called a deckle edge.

WATERMARK

The watermark is the identifying symbol of the paper manufacturer. It is most noticeable when using sheets. If you hold a sheet of watercolor paper at an angle, you will notice the name or symbol of the paper manufacturer. The placement of the watermark can change depending on the size of the paper. The side where the name is most legible is considered the right side of the paper. This side feels smoother and is the most consistent.

Watermarks
The watermark, usually found in the corner, is the symbol of the manufacturer embedded in the fiber of the paper.

Student-Grade Paper

Many student-grade watercolor papers absorb and accept color differently. Pigments will tend to lift too easily, mixing with other layers and resulting in muddy colors. When cut into smaller sizes, they have a tendency to curl more, making it difficult to work on.

paper preparation & storage

Watercolor paper is an organic product, so take special care when handling it.

TEARING PAPER TO SIZE

Instead of cutting your paper, tear it to size. By tearing, you create a torn edge that looks similar to a deckled one. This way, painting to the edge looks nicer, and you can float the piece when you have it framed. Fold your paper back and forth to weaken the seam. Once the seam becomes pliable, it's easy to tear.

PREPARING THE PAPER

Traditionally, most watercolor artists soak and stretch their paper before painting. This prevents buckling and allows you to use lighter weight (and less expensive) papers.

I find stretching to be both time consuming and unnecessary. Stretching paper removes the surface sizing, which then changes the flow of color for the initial wash.

I prefer to work with heavier 300-lb. (640gsm) paper because no preparation is necessary. I do not attach my paper to boards because I want my paper to be flexible and to bend if necessary.

The decision to stretch your paper or to work with heavier papers that don't require stretching is up to you. Both methods will work, but the results will be slightly different.

STORAGE

Watercolor blocks can be stored on a shelf just like any other book. Stack sheets of watercolor paper flat, and keep them in a cool, dry place, out of direct sunlight. Over time, too much sunlight can cause paper to yellow. If it's too dry, the paper can become brittle. If it's too damp, it may grow mold or attract dirt, and some colors may still bleed even after the painting is finished. Keep the temperature around 60 to 65 degrees Fahrenheit (16 to 18 degrees Celsius) and the humidity to 30 to 70 percent (it's better to be on the drier side).

Since watercolor paper is a cellulose product, it may seem tasty to some insects, who may make a meal out of your paper or a finished painting. Take the necessary precautions to protect your paper supply, and frame finished works.

Tip

Handle your paper as little as possible, and make sure that you do not have oil or lotion on your hands. These substances can act like a resist.

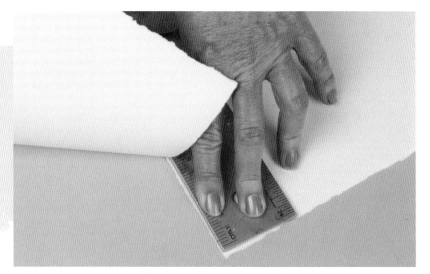

Tearing Paper

Fold your paper back and forth to weaken the seam, then tear along the edge of a table or use a straightedge.

other materials

Here are a few more essential materials that you'll need before you get started.

Paper towels are absorbent and can be useful for lifting out excess water or creating texture or clouds.

Terry cloth towels hold more water than paper ones, and are much more durable. Use them to help keep your painting surface clean and for removing excess water from brushes.

Water containers are essential tools for watercolor painting. If you use a small container such as a cup, the water will become dirty faster, and you'll have to change it often or your colors won't be bright and clean.

Using a larger container cuts down on a lot of running back and forth to the sink. A one- or two-gallon (four- or eight-liter) container is ideal. In a pinch, you can even cut a milk container in half, or try a large side-by-side dog bowl.

Hair dryers will speed up the drying process. Some artists claim that this will flatten or homogenize the color, but I find that a dryer works really well to prevent unwanted backwashes. Just be sure to apply the heat evenly.

Notebooks will help you keep a record of the colors used when painting. Your notebook can become an artist diary with thumbnail sketches and ideas as well as notes about your emotions, surroundings or even the music you were listening to.

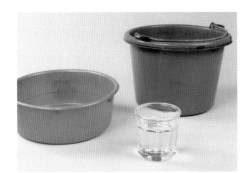

Water Containers

Use a large one-gallon (four liter) or two-gallon (eight liter) container for your wash bucket so you won't have to change your water as often. I prefer feed buckets, which I bought at a local feed store. They are colorful, sturdy and fun to use.

Tip

Use one water container for cleaning brushes and another for mixing color and applying washes.

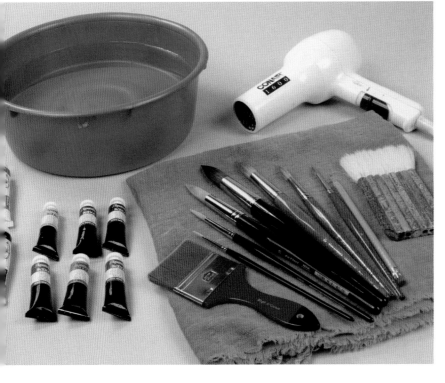

My Basic Materials List

- no. 30 natural-hair round
- nos. 8, 14, 20 sable/synthetic rounds
- nos. 3, 8, 20 synthetic rounds
- wash brush (2½-inch [6cm] bamboo hake brush, sky flow or mop)
- no. 2 pencil or B art pencil
- vinyl eraser
- plastic one-gallon or two-gallon (four- or eight-liter) water container
- 140-lb. (300gsm) Arches cold-pressed watercolor paper (for exercises)
- 300-lb. (640gsm) Arches cold-pressed watercolor paper (for paintings)
- plastic palette with cover
- paper towels
- hair dryer
- old terry cloth towel
- notebook (optional)
- transparent watercolors

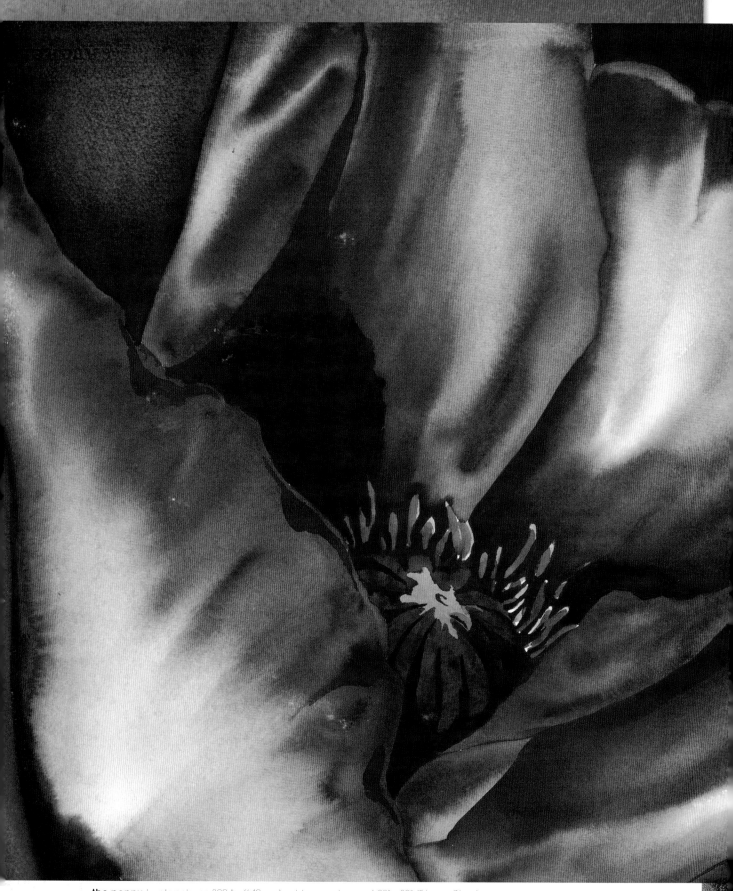

the poppy | watercolor on 300-lb. (640gsm) cold-pressed paper | 22" × 30" (56cm × 76cm)

CHAPTER 2:
color

Color has the ability to lift, rejuvenate, diminish or destroy. It can provoke emotion and sway thinking. As a personal experiment, sit for just a moment and ask yourself what color is happy? Sad? Angry? Your immediate response is the correct answer for you.

Watercolor is a fluid and expressive medium. Environment, music and sound can affect your choices in color and composition. Think of yourself as a filter with the ability to channel everything through and into a painting.

color basics

Watercolor always dries lighter than it looks when applied, so it is usually necessary to paint multiple layers to build rich, deep color. Some artists use up to a hundred layers, which can be incredibly time consuming. Knowing where and when to build color allows you to accomplish rich color in much less time, usually with only three or four layers.

After the initial application is completely dry, test it with the back of your hand; if it's cool to the touch, it is still too damp. If you apply another layer of color at this time, the previous color may lift. Once a color has had time to fully dry, it bonds to the paper and is less likely to lift.

For the second layer, reapply water with a soft natural or blend brush, then apply color only where needed. This is how you start to build natural transitions and color.

KEEP YOUR COLORS CLEAN

When learning how to paint, stick with transparent colors. Opaque and sedimentary colors have a tendency to become muddy. Transparent colors work best for glazing and will provide cleaner washes and more vibrant color.

Avoid mixing more than two or three colors at a time. Too many colors mixed together create mud.

When layering one color over another, start with lighter colors, then apply the darker ones. Lighter colors applied over darker ones can create a muddy appearance. Also, don't go too dark too fast or you may have to lift color back out, creating an overworked appearance.

The paper can also make a difference in keeping colors clean. Color doesn't adhere as well to some student-grade papers. Initial layers will lift when additional layers are applied.

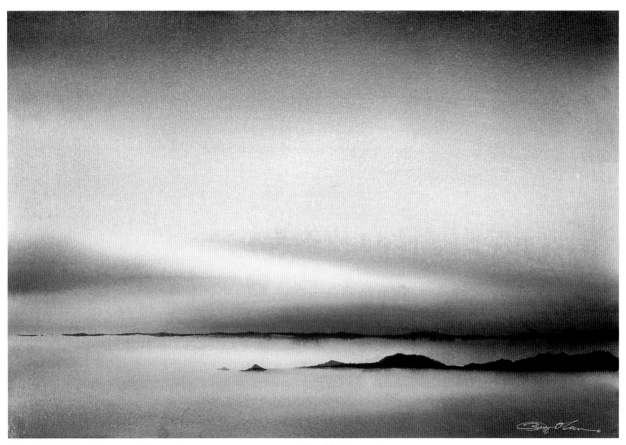

evening sky | watercolor on 300-lb. (640gsm) cold-pressed paper | 15" × 22" (38cm × 56cm)

Finally, simplify your sketch. Keep the pencil lines to a minimum since graphite can lift and mix into the color.

COLOR TERMS

Here are some basic terms commonly used when discussing color and color theory:

Local color is the true color of the object's surface.

Tint is a lighter color, created by diluting the pigment with water.

Shade is the darkening of a color by using black or the color's complement.

Tone/value refers to the lightness or darkness of a color. The more water you add, the lighter the color becomes.

Complementary colors are opposite each other on the color wheel. Mix complements to make neutral grays and browns or place them side by side to create a vibrant contrast.

COLOR TEMPERATURE

Warm colors (yellows, reds and oranges) appear to advance, while cool colors (blues, greens and purples) seem to retreat. Both colors can be very effective in expressing emotion. Warm colors give the impression of warmth and dryness, and evoke enthusiasm, animation and exhilaration. Cool colors give the impression of coolness and moistness and can evoke feelings of calmness or sadness.

Colorful Depth Perception
Warmer colors and darker values seem to come forward, while cooler colors and lighter values give the appearance of receding into the distance.

pigments

Some colors explode while others crawl. Some are more transparent and luminous while others are more opaque or granular. Experiment with a variety of pigments to learn about their different properties.

TRANSPARENT COLORS

Bright, clean, transparent colors are best for paintings with multiple washes and glazing. When you are just starting out, use transparent colors because they are less likely to create muddy colors. They allow light to pass through and reflect off the surface below, creating a jewel-like appearance. To increase transparency and luminosity in washes, add gum arabic, a binding liquid, to the pigment. This may leave a shiny residue on the surface that is desirable for some paintings.

OPAQUE COLORS

Opaque colors can cover previous washes and can change the tone of a painting. They do not allow as much light to pass through to reflect off the surface. They have a tendency to explode or bleed into newly applied color even after they've dried. Opaque colors can leave a flat appearance when dry and will become muddy when overmixed.

GRANULATING COLORS

Granulation is the speckled or mottled effect sometimes found in watercolor. Granulating colors can be either transparent or opaque pigments. These colors can add some really interesting effects and texture to a painting. The type of paper you use can add to this effect.

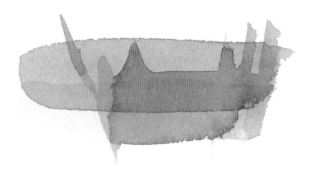

Glazing
Transparent color works best for glazing (see page 30). The clean washes allow light to pass through the layers of color and reflect off the paper's surface.

BASIC PIGMENT LIST

TRANSPARENT COLORS

Alizarin Crimson, Antwerp Blue, Aureolin, Brown Madder, Burnt Sienna, Burnt Umber, Cobalt Blue, Cobalt Blue Deep, French Ultramarine Blue, Gold Ochre, Green Gold, Hooker's Green, Indanthrene Blue, Indian Yellow, New Gamboge, Opera Rose, Permanent Alizarin Crimson, Permanent Carmine, Permanent Rose, Permanent Sap Green, Perylene Violet, Phthalo Turquoise, Prussian Blue, Quinacridone Gold, Quinacridone Magenta, Quinacridone Red, Raw Sienna, Raw Umber, Rose Madder Genuine, Scarlet Lake, Transparent Yellow, Ultramarine Violet, Viridian

OPAQUE COLORS

Bismuth Yellow, Cadmium Orange, Cadmium Red, Cadmium Red Deep, Cadmium Scarlet, Cadmium Yellow, Cerulean Blue, Cobalt Green, Cobalt Turquoise, Indian Red, Indigo, Light Red, Manganese Blue Hue, Magnesium Brown, Naples Yellow, Oxide of Chromium, Sepia, Venetian Red, Winsor Red Deep, Yellow Ochre

GRANULATING COLORS

Brown Ochre, Cadmium Red, Cerulean Blue, Cobalt Blue, Cobalt Turquoise, Cobalt Violet, French Ultramarine Blue, Lemon Yellow, Manganese Blue Hue, Magnesium Brown, Oxide of Chromium, Permanent Mauve, Raw Sienna, Raw Umber, Rose Madder Genuine, Terre Verte, Ultramarine Violet, Viridian

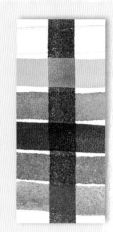

Test Your Colors
Test each color's transparency by placing a stroke of color over a dried brushstroke of India ink. Opaque colors will leave a residue and look as if they are on top of the black line. Transparent colors will show very little or no residue and appear as though they are behind the line.

STAINING COLORS

Some colors lift more easily than others. Staining colors adhere to the paper surface, making it difficult to remove color and retrieve the white of the paper. To test colors, create a swath of color and allow it to dry completely. Once dry, wet one side of the color and blot it with a paper towel or gently scrub it with a brush. You will be able to see which colors stain the most (see image at the bottom of the page). Staining colors have a tendency to be very powerful, so take care when mixing and add color gradually.

TRAVELING (BLEEDING) COLOR

All colors move differently. Some colors, such as Cadmium Yellow or Cobalt Blue, tend to explode across the surface, while others hardly move at all.

Often, if a darker color is applied first and allowed to dry, and then a lighter color is placed next to it, the edges of the darker color will bleed into the lighter color. Sometimes the opposite may be true as well. If an explosive lighter color such as Cadmium Yellow is placed next to a darker color that is still damp, the lighter color can travel and contaminate the darker color (see the image below).

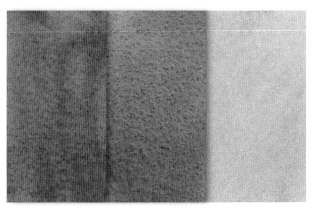

Granulating Colors
The Burnt Sienna and French Ultramarine Blue seem to separate, while the Winsor Green has a more consistent, even surface.

Traveling (Bleeding) Colors
The Cobalt Blue was almost dry when I placed the Cadmium Yellow next to it. See how invasive the yellow can be by the way it explodes and contaminates the blue.

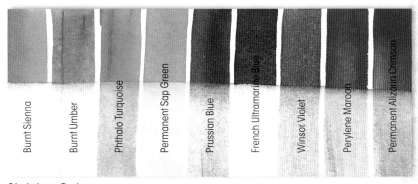

Burnt Sienna · Burnt Umber · Phthalo Turquoise · Permanent Sap Green · Prussian Blue · French Ultramarine Blue · Winsor Violet · Perylene Maroon · Permanent Alizarin Crimson

Staining Colors
Staining colors become embedded in the surface of the paper, making it difficult to retrieve the white of the paper.

Drying Effects

Watercolor dries up to 25 percent lighter when applied to a wet surface and up to 10 percent lighter when applied to a dry surface. Try to compensate by increasing the color strength of the first application. Layering is still necessary for tonal variations and depth.

mixing color

Many pigments directly out of the tube can be too strong or harsh. By mixing your pigments, you can save money and learn much more about color. Learning to use the correct ratios of water to pigment and color to color is essential to painting.

GLAZING

Apply color to paper and allow it to dry before placing another color on top. The first color will show through the second. This isn't technically mixing, but it is an effective way of combining and layering colors. The two colors combine, yet remain clear and distinct from each other. The effect of glazing is very different from that of simply mixing the two colors together on the palette.

COLOR PROPORTIONS

Mixtures do not have to be a fifty-fifty blend. Changing the proportions of each color will give you different hues within one color mixture. The final outcome will be up to you.

COLOR CHARTS

Make a color chart. This will help you see what you can create through mixing color. Post your charts in the studio. If your space is limited, use 8½" × 11" (22cm × 28cm) sheets of paper for each color and keep them in a folder.

RANGE OF HUE

Learn the range of hue you can create with just two colors. Increase one of the color's proportion to create a color range (see below). Experiment. This will give you an idea of the wide variety of color and hue you can mix.

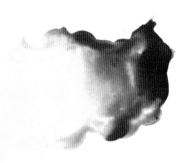

Color Proportions
Choose two colors and allow them to gently blend in the middle on your palette. Watch the range of color that is created.

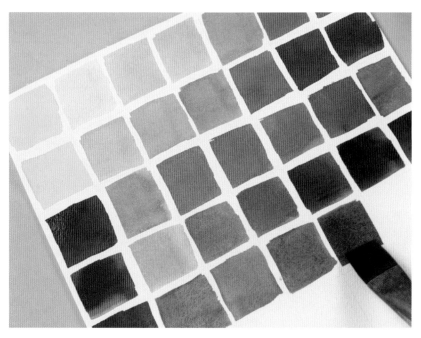

Range of Hue
Using a quarter sheet of watercolor paper, create seven rows of 1-inch (25mm) squares. Choose two colors for each row. Place the lighter color on the left and the darker one on the right. Starting with the lighter color on your palette, add a very small amount of the darker color, then place it into the square next to the lighter color. As you move across the row, gradually continue to increase the darker color so each square is slightly different.

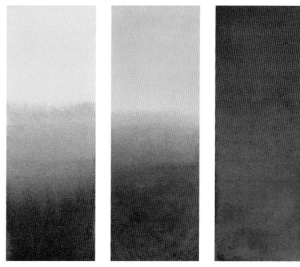

BLACK AND WHITE

In true transparent watercolor painting you never use black or white pigment. The lights are created by the reflected light from the paper's surface. It is best to build darker colors by mixing and layering. You can use Indigo for the darkest color, but avoid black paint as it will deaden your painting and make it look flat.

DARK BACKGROUNDS

Darker color can add to a painting and increase the drama, but black can easily flatten the piece and dull other colors. Try French Ultramarine Blue, Burnt Umber, Indanthrene Blue, Indigo or a combination of colors. If it still seems too light, add a little Indigo to the mix. See what works for you.

Creating Neutral Grays

To find a neutral gray, mix complementary colors in equal portions. Use a color wheel to determine complementary colors (they're opposite each other on the wheel). These colorful grays work well for shadows.

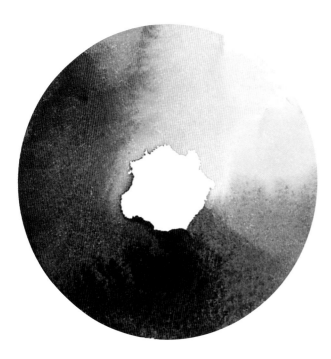

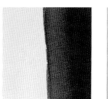 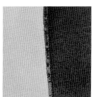

Making Color More Vibrant

Complementary colors mixed together create gray, but when placed side by side they enhance each other, making both more vibrant.

Tip

Each manufacturer's blend is slightly different, so test your colors so that you know what you're working with.

Try Different Darks

To deepen the color of the background, consider other colors rather than black. Notice the difference between Payne's Gray, Lamp Black, Indigo and Indanthrene Blue.

MAKING COLOR CHARTS

MIXING COLOR

MATERIALS

SURFACE
140-lb. (300gsm) cold-pressed paper

BRUSHES
no. 12 sable/synthetic blend round or ½-inch (13mm) flat

PIGMENTS
any or all of the colors in your palette

OTHER SUPPLIES
pencil or marker, ruler

All watercolor dries lighter than the initial application, so multiple layers may be necessary. The richest saturation of color happens when color is applied directly to dry paper because the color is less diluted.

1 MAKE A GRID
Using a ruler and a pencil or permanent marker, make 1-inch (25mm) or 1½-inch (38mm) squares on a 8½" × 11" (22cm × 28cm) piece (or up to a half or quarter sheet) of 140-lb. (300gsm) cold-pressed watercolor paper.

If you're computer savvy, download the PDF chart from my website at www.birgitoconnor.com and print them out as needed. Make sure your printer uses permanent inks so that the lines won't bleed when water is applied.

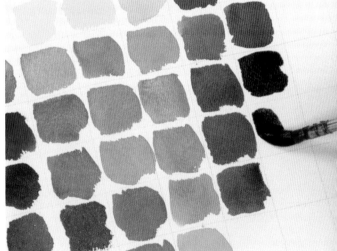

2 MIX COLORS ON THE PALETTE
Mix the colors on the palette to assure even blending and a good color mixture. Make sure to add enough water so that the color blends easily. The more water added, the more transparent the color will be.

3 WORK ONE ROW AT A TIME
Row by row, mix only one combination at a time. Mix one color from the left side and one from the top on your palette, then place the mixture in the corresponding square. Label colors as you go.

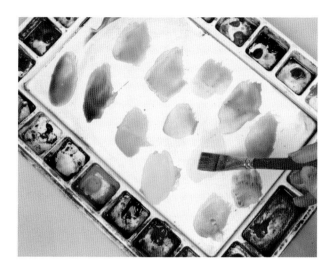

Speed Up the Process (left)

Mix your colors on your palette one combination at a time. Speed up the process in each row by creating different color stations of one color, then add another color to each station, then apply to the chart and label.

Completed Chart (below)

Use the colors you have on hand to create a color chart. You will be surprised at the wide variety of hues available to you by simply mixing color. The proportions of each color used will determine the color mixture.

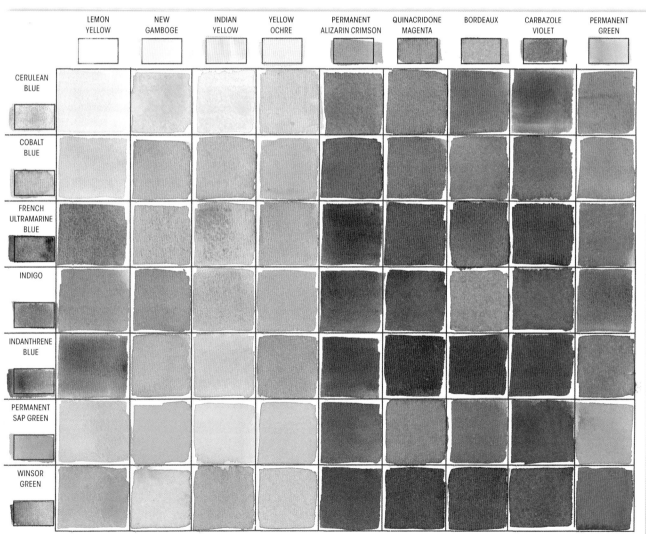

	LEMON YELLOW	NEW GAMBOGE	INDIAN YELLOW	YELLOW OCHRE	PERMANENT ALIZARIN CRIMSON	QUINACRIDONE MAGENTA	BORDEAUX	CARBAZOLE VIOLET	PERMANENT GREEN
CERULEAN BLUE									
COBALT BLUE									
FRENCH ULTRAMARINE BLUE									
INDIGO									
INDANTHRENE BLUE									
PERMANENT SAP GREEN									
WINSOR GREEN									

BLENDING COLOR

MATERIALS

SURFACE

140-lb. (300gsm) cold-pressed paper

BRUSH

no. 30 natural-hair round

PIGMENTS

any colors you choose

OTHER SUPPLIES

pencil or marker, ruler

Another way to combine colors is to blend them on the paper. This is a basic technique for creating natural transitions and smooth blending of colors. Once you understand how much water to use and how to move color around on the page, you will start to gain control and will become more comfortable with this medium.

Keep It Wet

Water is the vehicle for color to flow and blend. Learning how much to use is key. Watercolor cannot flow unless the surface is wet or damp.

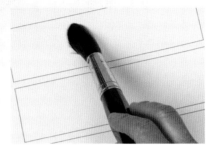

1 WET THE PAPER

Draw rectangles on your paper, leaving a ¼-inch (6mm) space between each row. Using a no. 30 round filled with clean water, wet one of the rectangles. The surface of the paper should glisten so that color can blend smoothly. If the shine disappears, the color won't be able to flow.

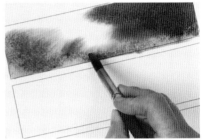

2 ADD THE COLORS

While the surface still glistens, place one color in the left corner and one on the right, then watch the colors move. If the paint is not moving there is not enough water mixed with the colors or the surface is too dry.

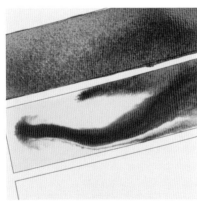

3 DIRECT THE FLOW OF COLOR

Direct the flow by lifting your paper. Notice how the colors stay only in the wet area. This gives you control over where the colors go.

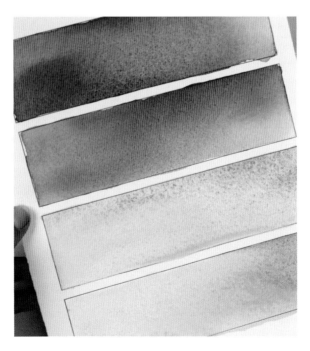

4 FINISH THE PAGE

Continue to work your way down the page. Take your time and work each rectangle individually. You can allow each color to dry in between or do them all at once. This will teach you about blending color, even natural transitions and drying times.

edges

Depending on your subject, the effect you want and where you want to stop your color, there are several ways to handle the edge of color.

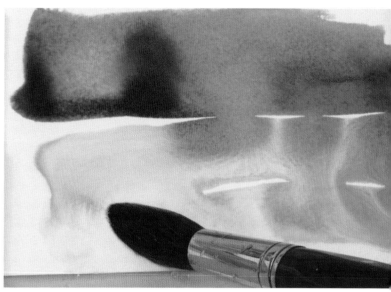

Use Water to Control Edges

Color can move only within the fluid medium of water. You can control the edge line with your brushstroke placement.

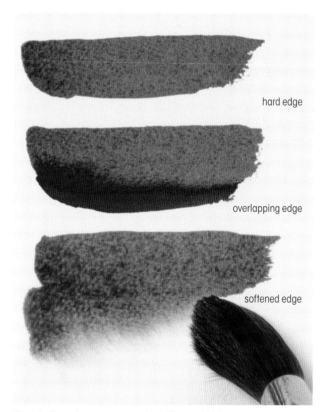

hard edge

overlapping edge

softened edge

Hard, Overlapping and Softened Edges

A hard edge (top) shows clarity. Overlapping edges (middle) result in a blending effect and create a third color between the two overlapping colors. This can make for some very interesting paintings but reduces the clarity of the piece. Softened edges (bottom) give the impression of one area flowing effortlessly into another.

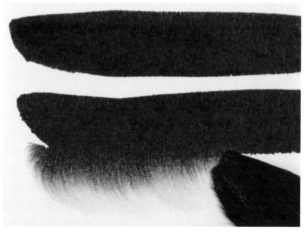

Softening an Edge Line

While the line is still damp, use a large, clean natural-hair brush to remove the excess water and gently pull the color out and along the edge. It is important to use a large enough brush so that the water does not stop short or wash back into the color and create an unwanted blossoming effect.

washes

There are several ways to apply washes. I like the tactile experience between the paper, paint, water and the artist. Most artists attach the paper to board before applying a wash. Using heavier weight papers helps eliminate buckling and warping.

Use a large natural round or large flat and enough water and color. Apply the wash in long, sweeping strokes. Work down the page, leaving an even layer of color.

Work quickly so that all of the areas dry at the same time, or the wash won't be even and you may leave visible brushstrokes in the wash. Try to avoid scrubbing back and forth or you may unintentionally lift the color and leave an overworked appearance.

Once you've applied the color, immediately lift the paper and tilt it side to side so that the color evens out. Remove any excess water on the table so that the color does not run back into the wash. Dry flat.

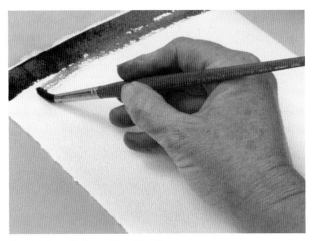

Avoid Small, Low-Quality Brushes
Use a brush that is large enough for the area. A brush that is too small or an inexpensive synthetic can leave a dry appearance.

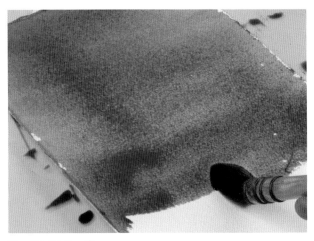

The Right Brush
A large, natural-hair brush holds more water and is less likely to leave unwanted brushstrokes.

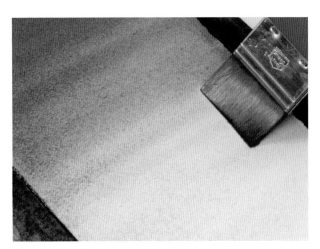

Graded Washes
First dampen the paper. Then, working in long sweeping strokes, apply color to the top. Lighten the value as you work down the page. Once an area has been covered, lift and tilt the paper so the brushstrokes even out, then allow the color to accumulate on one end.

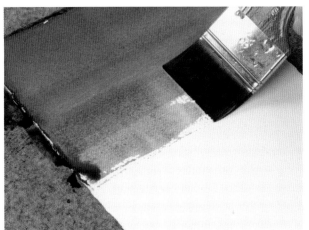

Working on a Dry Surface
Applying color directly to dry paper will give the richest color, but it will not be as luminous unless it is applied in very thin washes of color. Use the largest brush possible for the area to help eliminate unwanted brushstrokes.

Understanding how to create a smooth wash is essential to watercolor painting. These washes form the foundation of almost any painting, from the atmospheric skies and rolling hills of a landscape to soft still lifes and dramatic florals.

MATERIALS

SURFACE
140-lb. (300gsm) cold-pressed paper

BRUSHES
2-inch (51mm) bamboo hake, no. 30 natural-hair round

PIGMENTS
any pigments you choose

1 APPLY WATER
Use a large wash brush or bamboo hake to apply water (as in blending the color bars on page 34). The bamboo hake can lose hair easily. To remove loose debris, use a small synthetic brush.

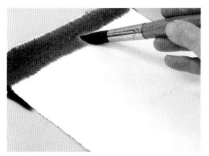

2 APPLY THE WASH
Make sure that the surface glistens, then apply the color. The amount of water will determine how easily the color blends.

3 SHIFT THE PAPER
Direct the flow of color by how you hold the paper.

Even Out Washes
If you need to even out any color, brush over the wash again with a large wash brush while the color is still damp, then lift the paper and tilt, allowing the color to blend. Wipe up any remaining color along the edges and dry flat.

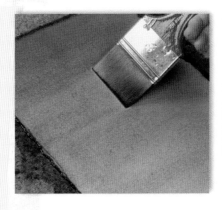

4 LET DRY
Then allow it to dry.

problems with washes

Here are some simple solutions for common problems with washes.

HARD WATERLINES

Reapplying water to an area before it is completely dry can dilute color and carry the pigment to the outside edges, where it will accumulate, leaving unwanted hard lines. The obvious solution is to allow areas to dry completely before reapplying water or color. If you do form a waterline, try to soften it with a scrub brush or reapply water and glaze over it.

GRAINY WASHES

Mineral pigments and sedimentary colors tend to create grainy washes. Leaving your palette uncovered allows dust particles to accumulate, which may result in unwanted texture. Using a hair dryer to dry the damp pigment can flatten the sediment in the wash.

WARPING AND BUCKLING PAPER

Watercolor tends to pool on lighter weight papers, often causing warping and buckling. Keep tilting your paper and moving the color to prevent pooling. A hair dryer will speed up the drying process. Hold it approximately 10" (25cm) away from the paper and keep the airflow moving evenly or you can end up with areas that have tried too quickly, leaving unwanted lines. See page 63 for more information on warped paper.

EXCESS WATER

To help control the drying time, remove excess water with a clean natural-hair brush. These are more absorbent than synthetic brushes. You can also use the tip of a paper towel, but don't press too hard or you may lift color, leaving an uneven dry area.

BACKWASHES AND BLOSSOMING

Two areas drying at different rates can create backwashes and blossoming. During the drying process, water from the wetter, slower drying area seeps into the drier area, resulting in a blossom. Sometimes these are "happy accidents," but they can also be a disaster.

If you have a very wet painting, try to keep an eye on it until it is almost dry— you never know what you will come back to. If a blossom has started to form, reapply water and pigment while it is still damp to even out the area. Remove the excess water and let dry.

Hard Waterlines

Hard waterlines appear when an area is overwet and the pigment travels out to the edges.

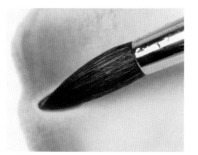

Absorb Water With a Brush Tip

A natural-hair brush acts like a sponge and will lift excess water out of an area. Natural hair is more absorbent than synthetic fibers.

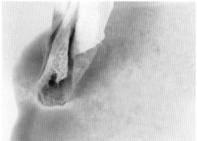

Absorb Water With Paper Towel

The edge of a paper towel easily lifts out excess water.

Keep the Surface Moist

A light spritz of water from a spray bottle can keep the color from drying too quickly.

take advantage of blossoming

Blossoming isn't always a disaster. Sometimes a blossom is a "happy accident" and can be incorporated into your painting. This works especially well with landscapes. It can also be a wonderful way to make a painting more interesting.

Backwashes and Blossoming

Backwashes can happen when one area is drying quicker than another or where color has pooled.

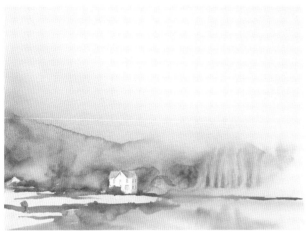

Improve Composition

Here backwashes help the composition, giving the impression of a hill line, trees and grasses.

gospel flat fog
watercolor on 300-lb. (640gsm) cold-pressed paper
23" × 30" (58cm × 76cm)

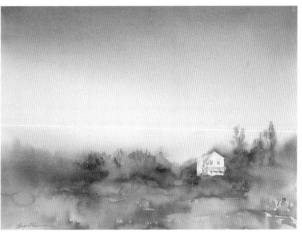

Create a Dreamy Quality

A mix of controlled edges and backwashes creates a soft, almost dreamy quality. Backwashes, blossoming and bleeding effects are noticeable in the foreground grasses, all of which lead the eye back into the distance to the tucked away cottage.

after the rain
watercolor on 300-lb. (640gsm) cold-pressed paper
22" × 30" (56cm × 76cm)

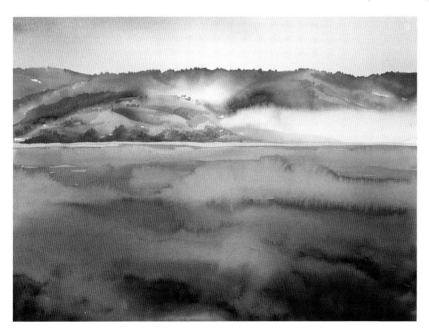

Simplify Details

Use backwashes to your advantage to give the impression of grasses without having to paint every blade.

pickle weed
watercolor on 300-lb. (640gsm) cold-pressed paper
22" × 30" (56cm × 76cm)

from the shadows | watercolor on 300-lb. (640gsm) cold-pressed paper | 40" × 60" (102cm × 152cm)

CHAPTER 3:
value

At first glance most people don't really notice values. They may see light, medium and dark, but it's the subtle transitions between these areas that are critical to a painting's success. These values are what give an image shape, depth and distance. They are some of the most essential elements to a painting. Without proper use of value, a painting can appear flat.

To identify values, look at a scene or object and squint to simplify what you see by breaking it down into three main parts: light, medium and dark. Then, look within these areas for the more subtle variations. You will notice the light areas are not all the same value, and shadows vary as well. Value depends on how much light is able to penetrate or reflect off a surface or object.

identifying values

Here are some simple techniques that will help you learn to identify values. Try them all and see what works best for you.

SQUINT YOUR EYES

Simplify what you see by squinting your eyes. This eliminates unnecessary details and allows you to focus on the basic shapes, color and shades of gray.

MAKE A PENCIL SKETCH

Draw a thumbnail sketch with pencil only. This forces you to build shape and shadow using only one color.

RED FILM

If you are in the field or need a quick reference, use a piece of red film or acetate (available through photography suppliers or many craft stores) to simplify your subject. The red film removes all other colors, leaving only variations of light and dark.

MAKE A BLACK-AND-WHITE COPY

If you are using photographs or digital prints, make a black-and-white print, or, if you don't own a printer, make a photocopy. The black-and-white print can make it much easier for you to see the subtle changes you might be missing.

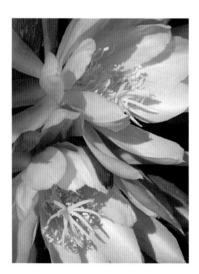 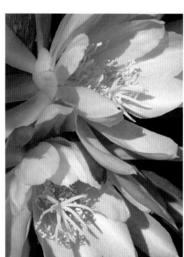

Color vs. Black-and-White Photos
It is much easier to see values clearly in a black-and-white photo.

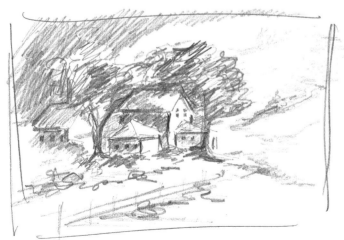

Sketching Values
A simple pencil sketch will help you simplify the values in your composition.

Once you are able to identify values, recreating them in watercolor is really quite simple. Values in watercolor are completely based on the amount of water added to the color.

The beauty of watercolor is in its transparency, which is why it is important to know how much water to use and how it will affect the color. If you do not use enough water, the color will appear more opaque, which can leave a painting looking flat. Too much water creates weak and wimpy looking color. This exercise will help you learn the right balance of water and color.

MATERIALS

SURFACE
140-lb. (300gsm) cold-pressed paper

BRUSH
½-inch (13mm) flat

PIGMENTS
any or all of the colors in your palette

OTHER SUPPLIES
pencil or marker, ruler

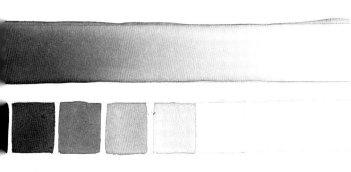

1 CREATE A VALUE STRIP
Using one color, blend it well on the palette with a little water, creating a nice consistancy. Then, apply the color at its full strength on the left side of a piece of scrap paper. Add a little more water to the remaining color on the palette and blend this next to the original color on the strip. Create separate squares or a blended strip. Gradually increase the water, allowing the color to wash out until it is almost transparent. This will show you how many different shades and variations you can achieve with just one color.

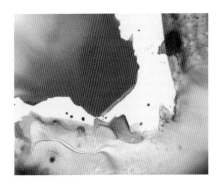

2 MAKE A VALUE CHART
Repeat Step 1 on a larger piece of paper (8½" × 11" [22cm × 28cm] or a quarter sheet of cold-pressed paper). Create a grid of six 1-inch (25mm) squares across and down. In the first row place the color at its full strength, then gradually increase the water diluting the color as you move across the page. Continue to dilute the color until it is almost transparent.

3 WATER CHANGES VALUE
Pay attention to how much water you use while mixing color. As you gradually create lighter colors, more and more water will be on the palette. Notice how the darker value has the most concentrated color.

painting values

The basic concept for painting values in watercolor is simple: Start with your lighter color and values, then work towards the darks. If you go too dark too fast, you may overwork areas. Try to avoid adding color and then having to lift it back out. This can damage the surface of the paper or leave unwanted rings around the area of color.

SHADOWS AND VALUE

Shadows are an important element in creating the illusion of depth. The amount of light that is able to penetrate an object affects its shadow, changing its value. If you use only one value or color to create shadows, your painting will likely look flat and the shadow will appear separated from the rest of the painting.

Although a shadow may appear to be a single color, there is usually enough ambient or reflective light to create some subtle variations in value. Add colors or slightly change the value in a few areas of the shadows to make the painting more interesting.

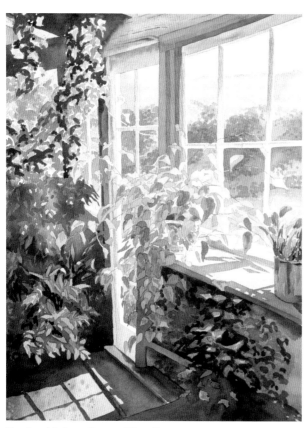

Darker Values Draw Attention

The shadow is really the most effective element in this painting. As light passes through the window, the shadow draws the viewer's attention from the window panes down to the floor. It's not necessary to create details in the darker areas. I used a no. 8 sable/synthetic blend round to pull abstract shapes from the negative space, creating the illusion of vegetation.

garden window
watercolor on 300-lb. (640gsm) cold-pressed paper
30" × 22" (76cm × 56cm)

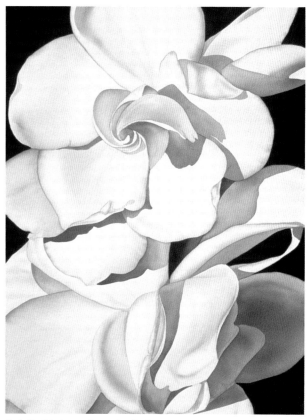

Subtle Values Create Softness and Depth

Subtle values give a softer appearance and can create levels of depth within a painting. They can make it seem as though an object is projecting light or that light is penetrating the surface. Without these softer, subtler values and shadows, a painting may appear flat.

innocence
watercolor on 140-lb. (300gsm) cold-pressed paper
40" × 25" (102cm × 64cm)

values & contrast

Changes in value help create contrast, and contrast creates interest. The viewer's eye is drawn to contrast. The placement of values and contrast can make a big difference.

Degrees of Contrast

Here you can see the effects of varying degrees of contrast. The contrast of light and dark shapes helps an image to stand out. Medium values are more subtle, but they still provide enough contrast to create depth.

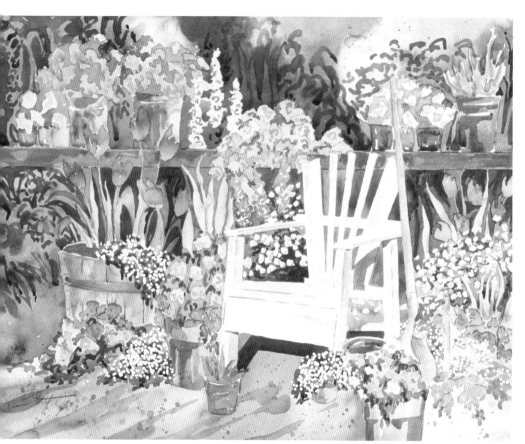

Carefully Planned Contrasts

I reserved the highlights of the chair and applied a multicolor wash to the background. I then pulled shapes out of the negative space. I applied masking to preserve smaller flowers and details before applying the wash.

garden chair
watercolor on 140-lb. (300gsm) cold-pressed paper | 15" × 22" (38cm × 56cm)

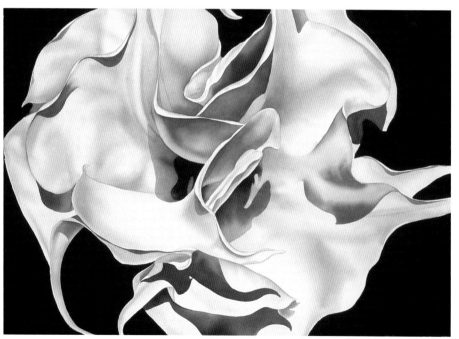

Contrast Creates Interest

High contrasts and subtle values create the shape. Since the palette is limited to French Ultramarine Blue, Burnt Umber, Burnt Sienna and Indigo, values play an important role in making this image interesting and mysterious.

oota
watercolor on 300-lb. (640gsm) cold-pressed paper
22" × 30" (56cm × 76cm)

values create depth & distance

Properly placed contrasts can be used to create depth for an object. A dark, contrasting background can help propel the main subject forward or even give the impression that the viewer could almost touch the object.

Contrast can also create the illusion of distance in a painting. For example, placing darker values in the middle or foreground of a landscape gives the viewer a starting point, then the lighter values in the background will give the impression of distance.

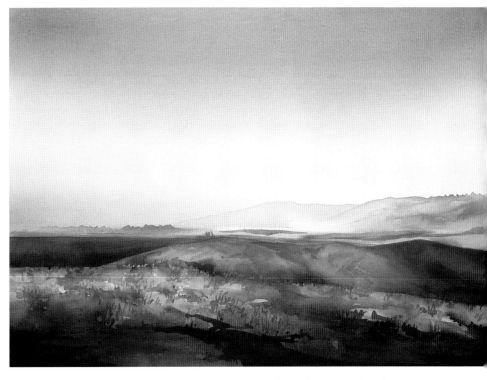

commonweal
watercolor on 300-lb. (640gsm) cold-pressed paper | 22" × 30" (56cm × 76cm)

Value Changes Create Distance (above)
Darker color in the foreground or middle ground gives the viewer a starting point. As the eye moves into the distance, the value gradually gets lighter due to atmosphere and light.

Value & Composition Work Together (left)
Here the composition draws the viewer's eye to the lightest values in the distance.

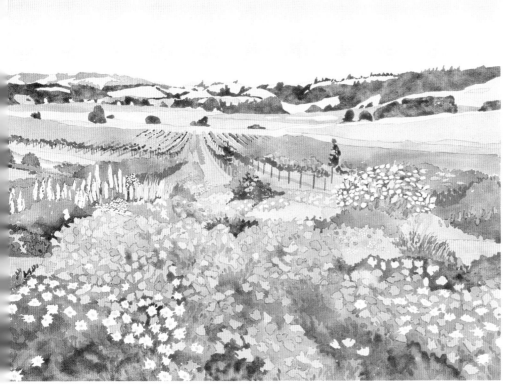

navarro winery
watercolor on 300-lb. (640gsm) cold-pressed paper
22" × 30" (56cm × 76cm)

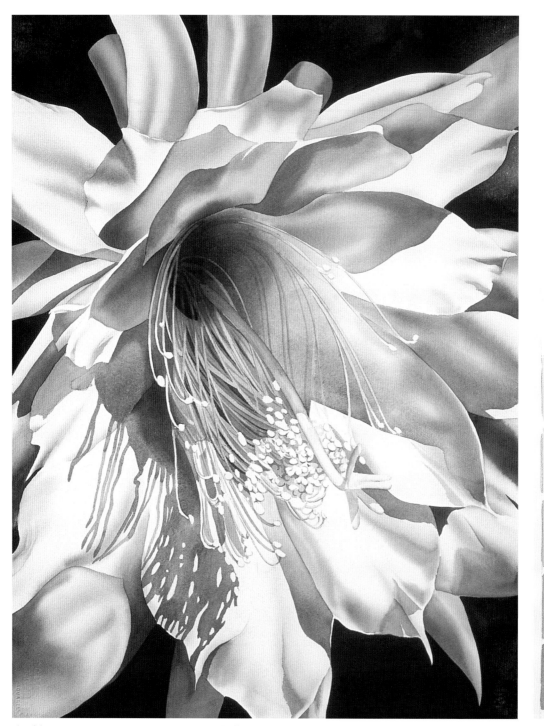

star bloom
watercolor on 300-lb. (640gsm) cold-pressed
paper | 30" × 20" (76cm × 51cm)

Different Values Create Depth

A combination of Cobalt Blue and Burnt Sienna creates a soft gray,
which works well for the more subtle shadows of the stamens. These
shadows help "lift" the stamens off the page. Different values are key
to the illusion of depth.

VALUES CREATE DISTANCE

When you look off into the distance of a landscape, you will notice that the farther you can see, the lighter the value becomes. Atmospheric conditions cause color and shape to become less defined. This concept is called *atmospheric perspective*. Using only one color in this exercise will help you understand value and distance. It will also show you how to deepen color by layering and to create smooth lines.

MATERIALS

SURFACE
140-lb. (300gsm) cold-pressed paper

BRUSHES
no. 20 sable/synthetic blend round,
wash brush

PIGMENT
Indanthrene Blue

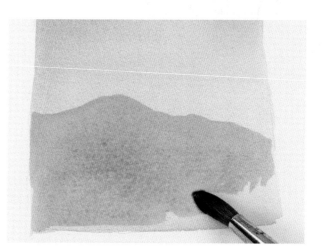

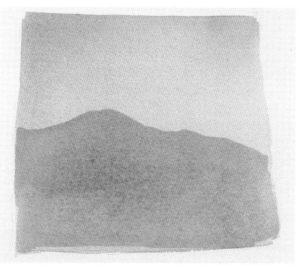

1 APPLY A WASH OF COLOR
Starting at the top, apply a wash of the lightest value to the sky and background, bringing the color and water all the way down to the bottom. Let dry.

2 RIDGELINE
Using the no. 20 round and a slightly darker value of the same color, create the farthest ridgeline. Make sure to use enough water so that all the areas dry at the same time. Bring the color all the way down to the bottom of the page. Let dry.

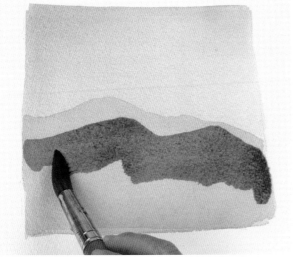

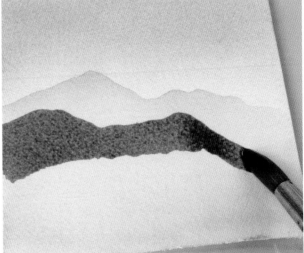

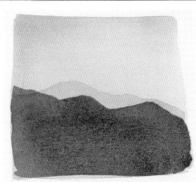

3 CREATE A SECOND RIDGELINE

Using a darker value, place another ridgeline slightly below the previous one. Again, bring the brushstrokes all the way down to the bottom of the page so that the color appears even. Do not stop short or you may create unwanted overlapping lines and separated sections. Glazing the new color over the previous layer creates richer color with deeper values.

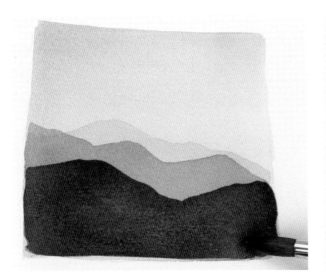

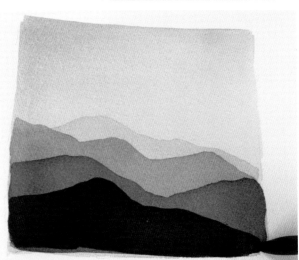

4 CONTINUE CREATING RIDGELINES

Continue creating ridgelines and deepening the value, allowing each layer to dry before applying the next. Three to five levels (odd numbers are best) will create the illusion of distance. If you want to imagine a very clear day, try up to seven levels.

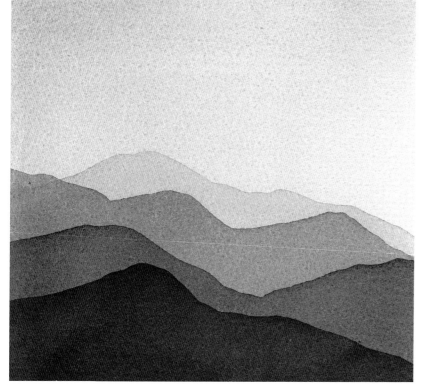

Finished Painting

Dramatic value changes from dark to light help give the viewer a starting point and then leads the eye through different values into the distance.

blue ridge mountains
watercolor on 140-lb. (300gsm) cold-pressed paper | 10" × 12" (25cm × 30cm)

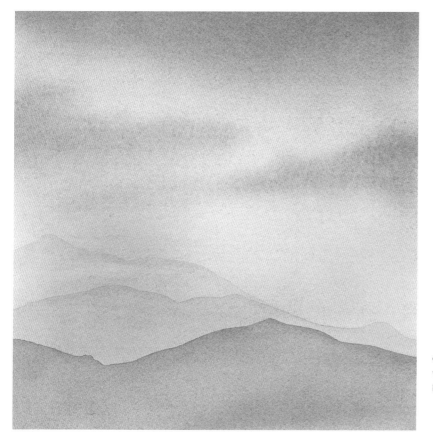

Experiment With Color

Try the same exercise with different colors—maybe even with a wet-into-wet application for the sky. This is an easy way to give the impression of a sunrise or sunset.

autumn sky
watercolor on 140-lb. (300gsm) cold-pressed paper | 12" × 10" (30cm × 25cm)

MATERIALS

SURFACE

140-lb. (300gsm) cold-pressed paper

BRUSH

1-inch (25mm) flat

PIGMENTS

Burnt Umber or Burnt Sienna, Sepia

OTHER MATERIALS

pencil

Starting with a simple shape, reserve the highlight, then allow the shading, layering and value changes to do the rest.

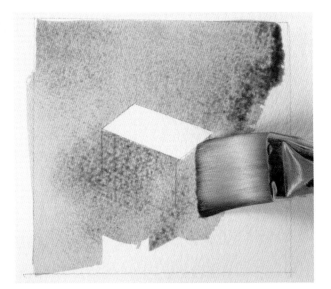

1 RESERVE THE HIGHLIGHT

Use a pencil to sketch a simple shape as a guide. With a 1-inch (25mm) flat, apply a wash of color. Reserve the area where the highlight will be. Let dry.

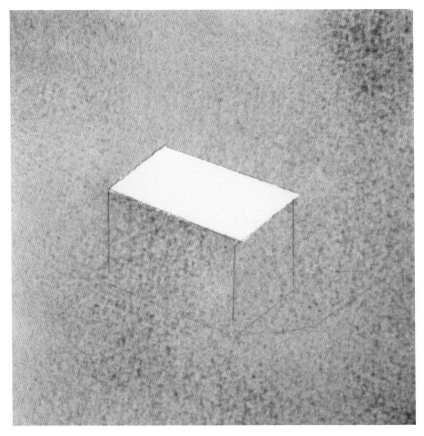

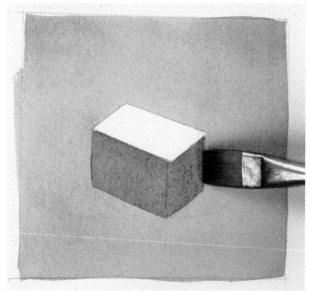

2 DEFINE THE SHAPE

Using the 1-inch (25mm) flat and the same color in a slightly deeper value, start to define the shape of the sides of the box. Let dry.

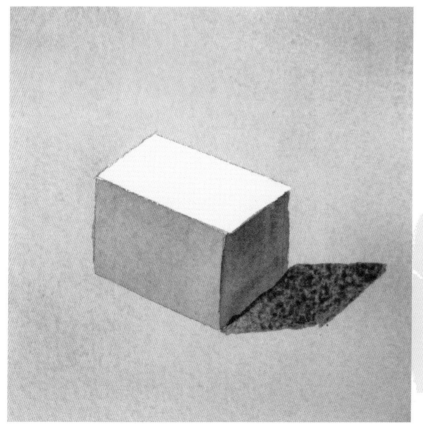

3 CREATE THE SHADOW

To give the three-dimensional illusion of depth, place the darkest shadow to one side and out along the base of the box.

Shadow Placement

Shadows are always opposite the light source. The precise location of the shadow is determined by the direction of the light.

SIMPLE SHAPES IN ACTION

MATERIALS

SURFACE
140-lb. (300gsm) cold-pressed paper

BRUSHES
*large wash brush, flat wash brush,
nos. 14, 20 sable/synthetic blend
rounds, no. 30 natural-hair round*

PIGMENTS
Burnt Sienna, French Ultramarine Blue

OTHER MATERIALS
pencil

Blend two colors to make a nice warm gray. I used French Ultramarine Blue mixed with Burnt Sienna. Choose a simple composition with obvious light and dark areas to practice using simple shapes and shadows.

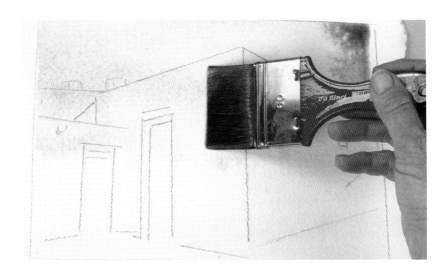

1 APPLY A WASH
Apply a thin wash of the lightest value over the pencil sketch. Let dry.

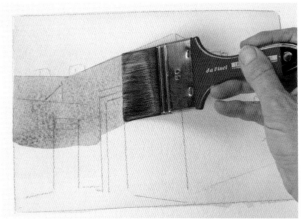

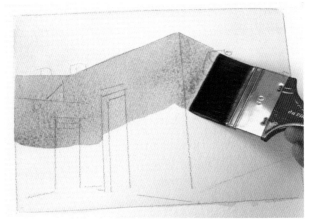

2 DEFINE THE SHAPE
Using a large wash brush, apply a slightly darker value of the same color combination over the shape of the subject. The larger wash brush covers areas quickly, keeps color constant and creates angular lines. Let dry.

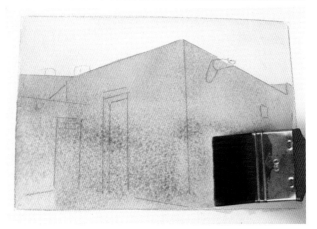

3 CREATE THE SHADOWS

Using different values, add the shadows. Adjust the color as needed by using more water or pigment.

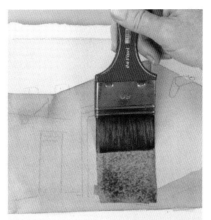
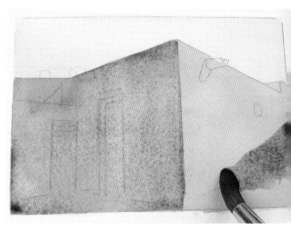

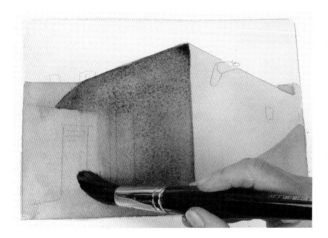
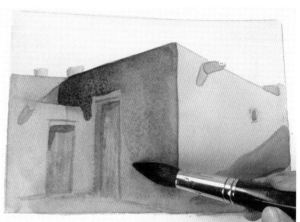

4 SOFTEN THE EDGES

Color may vary from light to dark with a combination of hard and soft edges. To eliminate unwanted hard lines, use a clean, damp (not wet) no. 30 natural-hair round. For finer details, use a no. 14 or no. 20 round sable/synthetic blend round.

new mexico pueblo
watercolor on 140-lb. (300gsm) cold-pressed paper | 11" × 15" (28cm × 38cm)

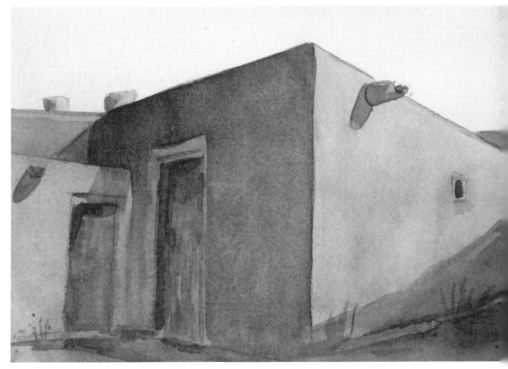

VALUE CHANGES FOR SOFT FORMS

MATERIALS

SURFACE
300-lb. (640gsm) cold-pressed paper

BRUSHES
no. 30 natural-hair round, nos. 8, 14, 20 sable/synthetic blend rounds

PIGMENT
Indanthrene Blue

OTHER MATERIALS
pencil

Different shapes require different approaches. When working with negative space, the images tend to be boxy and flat. For a softer appearance, instead of pulling the shape out of a wash, work in individual areas to create more dimension and depth.

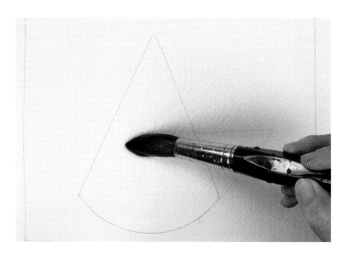

1 LIMIT THE WET AREA
Using a no. 30 natural-hair round, apply clean water inside the lines of the cone. Go almost to the pencil line, but leave a small dry area between the lines and the wet area.

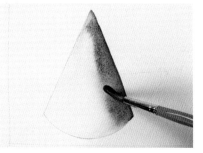
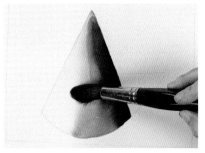

2 ADD COLOR
Using a no. 8 sable/synthetic blend round, apply color along the pencil line of one side of the cone from top to bottom, and along the bottom to the center of the cone. Allow the color to gently blend into the clean water. To avoid feathering, lift and tilt the paper and direct the flow of color. To prevent blossoming, remove excess water with a no. 30 natural-hair round. Let dry.

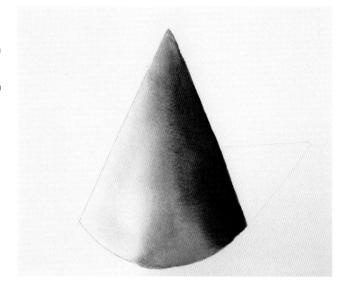

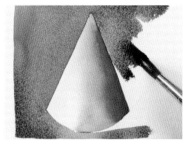

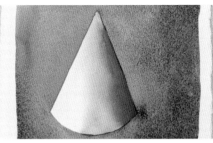

3 ADD A BACKGROUND

Use a no. 20 sable/synthetic blend round to apply the same color in a darker value to the background. The larger blend brush covers an area quickly because the fibers hold more water and color while still giving you the control you need. Let dry.

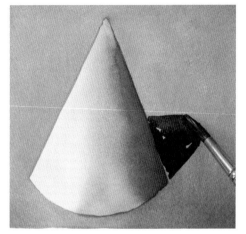

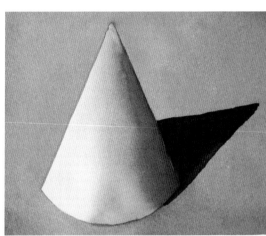

4 ADD A SHADOW TO GROUND THE CONE

Use the darkest value possible and a no. 14 sable/synthetic blend round to create a deep, contrasting shadow. The shadow will be opposite the light source.

5 FINISH THE PAINTING

Notice how the background and shadow help give the impression that the cone is lifting off the paper. The contrast of the darker background with the high-lighted area of the cone helps to add shape.

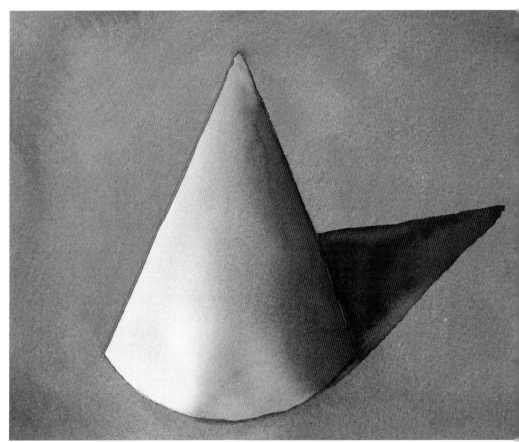

SHAPING

MATERIALS

SURFACE

300-lb. (640gsm) cold-pressed paper

BRUSHES

no. 8 synthetic round, nos. 8, 14, 20 sable/synthetic blend rounds, no. 30 natural-hair round

PIGMENT

Indanthrene Blue

Moving beyond a simple shape, we will work on creating multiple dimensions within an object. Painting this simple pot requires you to locate the light source and the reflective light, utilize contrast and learn how to create a rounder shape and a depression in the center. Use only one color to help you find different values within one subject.

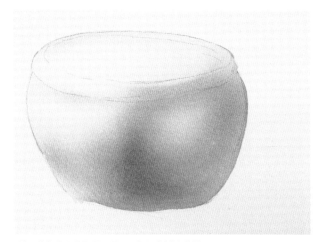

1 CREATE THE POT SHAPE

Work one area at a time, starting with the pot. Apply water and then color using a no. 14 sable/synthetic blend round. This brush size will help you control the color and reserve areas for highlights.

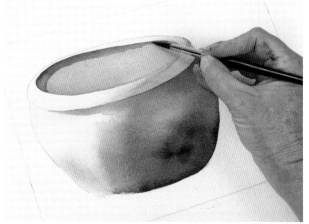

2 DEVELOP THE DETAILS

Once the initial application of color has dried, use a no. 8 synthetic round to apply some of the finer shadows details along the lip of the pot.

3 ADD THE BACKGROUND

After you have developed the shape of the pot, use the darkest value possible to add the background. Using a no. 20 sable/synthetic blend round, add color to dry paper. This contrast will force the lighter areas forward while pushing the darker ones into the background and creating a sense of drama. The variations in value help create the illusion of the pot lifting away from the page.

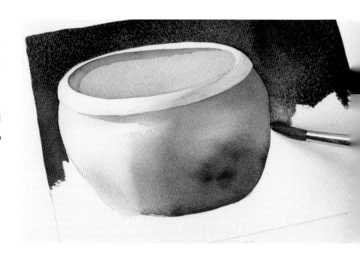

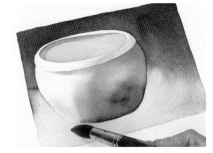 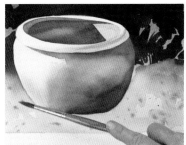

4 LIGHTEN THE FOREGROUND

Using a no. 30 natural-hair round, soften the background so that the value gradually lightens towards the foreground. The larger natural-hair brush allows you to easily pull the color down to the bottom of the page without one area drying quicker than another. Let dry.

5 ADD THE DETAILS

At this stage the piece still appears flat. Deeper values are necessary to give the impression of depth. Remember, watercolor always dries lighter, so add another layer to the background. To capture the darkest value possible, apply color to dry paper.

Next, work the negative space behind the pot to create detail and give the impression of vegetation. Too much detail can distract from the main subject, so abstracted shapes work well. They give the idea of something more without creating a distraction. To create the pebbles, use a no. 8 sable/synthetic blend round to splatter different values of the same color as well as clean water into the foreground (see page 76).

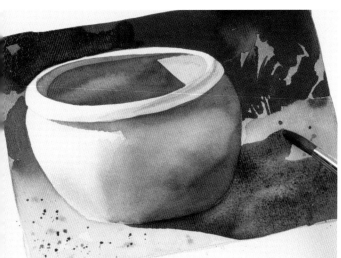

6 ADD THE SHADOWS

Once you are satisfied with the body of the painting, start adding the shadows. Apply the darkest value to dry paper with a no. 14 sable/synthetic blend round. Remember, the shadow is opposite the light source.

7 DEGREES OF VALUE

The darkest value is under or closest to the pot. As the shadow moves out and away from the pot, more ambient light is able to penetrate and the value becomes lighter.

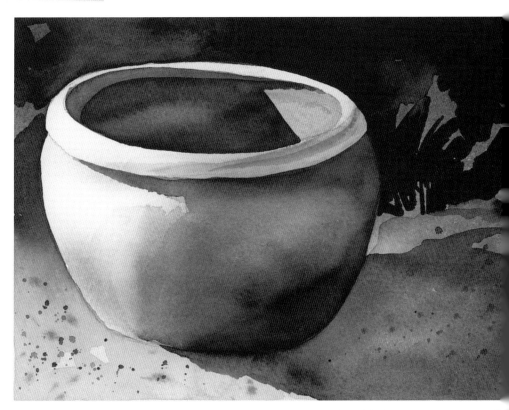

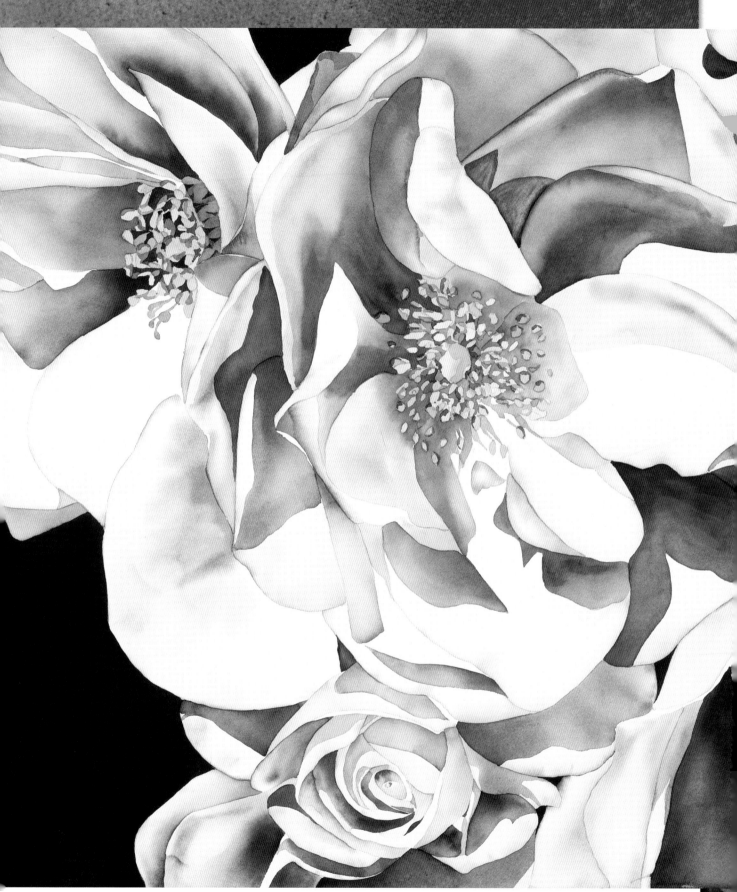

shadow dance | watercolor on 140-lb. (300gsm) cold-pressed paper | 25¾" × 40" (65cm × 102cm)

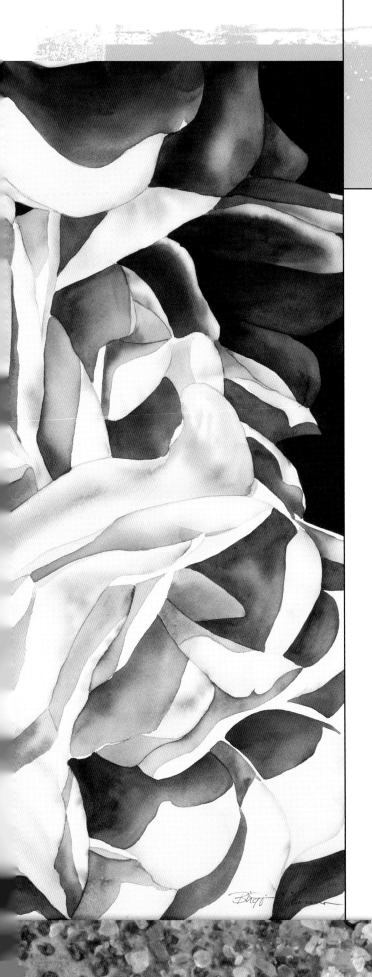

CHAPTER 4:
techniques

A number of techniques and mediums can be used to create different effects in your paintings. You can even use household items such as salt, coffee grounds, sand, plastic wrap, rubber cement, wax paper or foil in the techniques. Use these techniques in the underpainting, limit them to the backgrounds or foregrounds, or apply them all over to change the texture and make your paintings more interesting.

Don't worry about making mistakes because there aren't any. Get rid of the expectation that you always have to create great art. By experimenting and having fun you will find some of your greatest successes.

common problems

There is usually some way to fix a problem, but, in general, it is best to avoid them if you can. Taking your time and using the right weight of paper can really help. In a pinch, here are some techniques you can use to fix common problems such as color that is too dark, damaged paper, holes and divots, loose hairs and warped paper.

LIFTING WITH A ROUND BRUSH

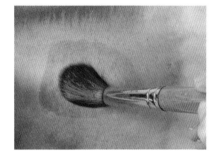 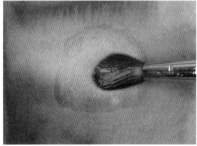 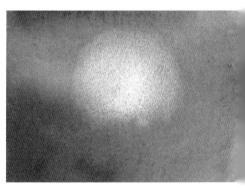

LIFTING WITH A SCRUBBER BRUSH

 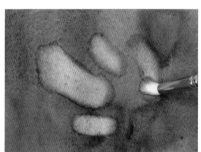 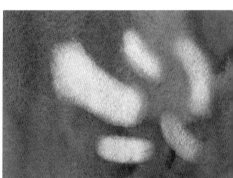

Lifting Color

To retrieve highlights and lift color, rewet areas with water, then lift with a brush, paper towel or scrubber brush. This works well for dappled light in backgrounds, reflective light on water highlights, or to soften edges.

LIFTING WITH PAPER TOWEL

Lifting Preparation

Lifting preparation is a medium that dries washes (including staining pigments) so that they can be more easily lifted from paper with a wet brush or sponge. You can use this medium to make corrections or to add highlights to your work.

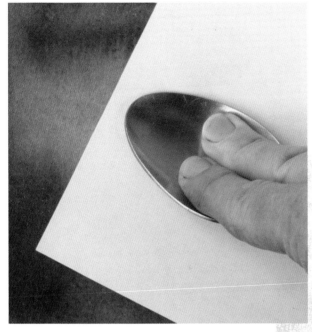

Repairing Damaged Paper

Lifting and scrubbing color can easily damage the paper surface, leaving an overworked appearance when color is reapplied. To help repair these areas and smooth out the paper fibers place a sheet of notebook paper over the area, then rub a spoon over the paper, burnishing it to flatten the fibers back into position. Rubbing the spoon directly over the watercolor paper will create an area that is too shiny.

Repairing a Hole or Divot

To repair a small hole, add a little gesso to the area, then apply a small piece of torn paper. Once dry, burnish the surface with notebook paper and a spoon to reflatten the fiber. This works very well for some areas, but it will be more noticeable if the hole is in an area of large washes of smooth color.

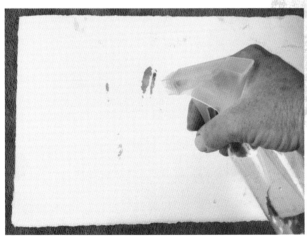

Warped Paper

Lighter weight papers have a tendency to buckle if not attached to a board.

The fastest way to flatten a buckled painting is to lay the painting face down on a clean towel, spray the back with clean water, then use an iron on a low heat setting to gently iron the back. Don't set the heat too high or the paper may curl in the opposite direction.

Lifting a Loose Hair

Some brushes such as the bamboo hake tend to drop hair into a wash. Often, you don't see a hair until after you've applied the color. If this happens, use a small synthetic brush to gently lift the hair out. Natural or blend brush fibers are too soft and hold too much water. Removing it with your fingers will damage the paper surface.

painting wet-into-wet

Applying color to a wet surface creates a softer, less controlled effect. To prevent colors from overmixing into mud, leave a buffer space between colors so that they gently blend into each other. You can use this technique for an entire painting, or try using it in the backgrounds or in a limited area to create subtle suggestions. If you decide that you want greater detail you can always form more detailed images out of the negative spaces you've created.

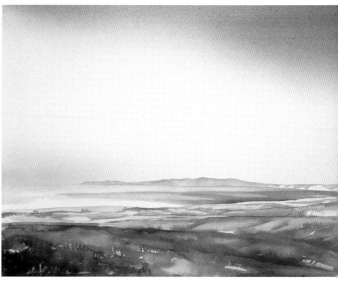

The Impression of Grass

I used the wet-into-wet technique to create the grasses in this minimalist landscape. Try the exercise on the next page to practice painting grasses with the wet-into-wet technique.

drakes bay, 2001
watercolor on 300-lb. (640gsm) cold-pressed paper
22" × 30" (56cm × 76cm)

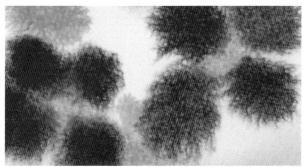

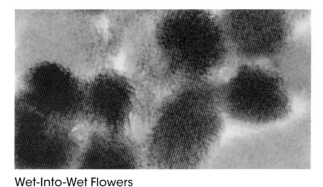

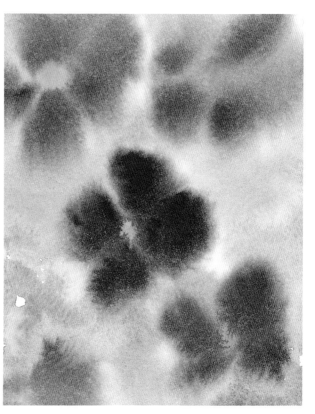

Wet-Into-Wet Flowers

Wet the surface with clean water. When the surface no longer glistens, apply color with a damp brush, allowing the edges to softly blend.

64

Most people think they need to paint every blade of grass and every detail. Unfortunately, this style of painting can easily look overworked. A much better approach is to use the wet-into-wet technique and give the impression of grassland with minimal detail.

MATERIALS

SURFACE
140-lb. (300gsm) cold-pressed paper

BRUSHES
nos. 8, 14 sable/synthetic blend rounds, no. 30 natural-hair round, bamboo hake or large wash brush

PIGMENTS
Burnt Sienna, Burnt Umber, Cobalt Blue, Permanent Sap Green, Yellow Ochre

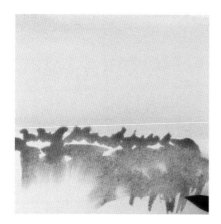
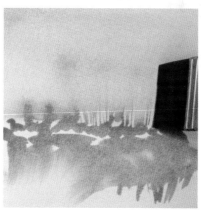
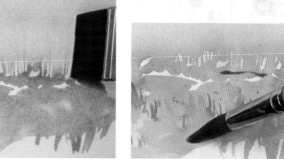

1 APPLY COLOR
Randomly apply brushstrokes of color to give the impression of grasses.

2 SOFTEN THE EDGES
While the color is still damp, use a large round or a flat wash brush to soften some random brushstrokes and edges in the background. Clean water bleeding back makes intentional blossoming, creating more texture. Softening the edges lets the viewer know that there are more grasses without creating a stiff, overworked appearance.

3 ADD DETAILS
As the color dries, it will begin to lighten. Use a no. 8 sable/synthetic blend round for details and to create the impression of other grasses.

4 PULL OUT MORE SHAPES
Using the previous wash of color, pull more grass and details out of the negative space. Soften some of the edges. Let dry.

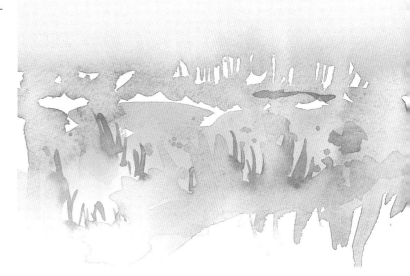

MATERIALS

SURFACE

300-lb. (640gsm) cold-pressed paper

BRUSHES

nos. 14, 20 sable/synthetic blend rounds, bamboo hake or large wash brush

PIGMENT

French Ultramarine Blue

OTHER SUPPLIES

paper towels

Depending on the effect you want there are different ways to approach painting clouds. Some basic techniques are to apply color to dry paper, paint wet-into-wet (see page 64) or lift color using a paper towel. Here are the techniques for creating a few cloud types.

BIG BILLOWY CLOUDS

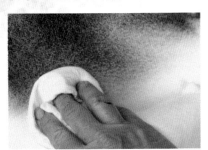

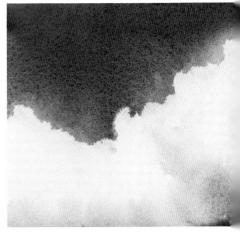

1 APPLY COLOR

Apply water with a large brush to the entire area. Then, with a no. 20 sable/synthetic blend round, apply French Ultramarine Blue starting at the top to about half way down the paper. The darker the value, the more dramatic the effect.

2 LIFT COLOR OUT

While the color is still wet, use a paper towel to lift water and color out of the cloud areas. Paper towels have different textures. For softer, billowy effects, use soft, absorbent paper towels that don't have an imprinted texture (such as Viva).

3 TILT PAPER

Tilt the paper and allow the color to run down so that it settles along the edges where the water and color were lifted.

SIRIUS CLOUDS OR AIRPLANE CONTRAILS

Apply Diagonal Brushstrokes to Damp Paper

Using a large wash brush, dampen the paper. As the glisten leaves the surface, use a no. 14 sable/synthetic blend or synthetic round to randomly apply color in diagonal brushstrokes. The areas without color create the impression of soft cirrus clouds or contrails.

BRUSHSTROKE CLOUDS

Create Deliberate Edges With Brushstrokes

Hold a large no. 20 sable/synthetic blend round at an angle and apply French Ultramarine Blue to dry paper, catching the tooth of the paper's uneven surface.

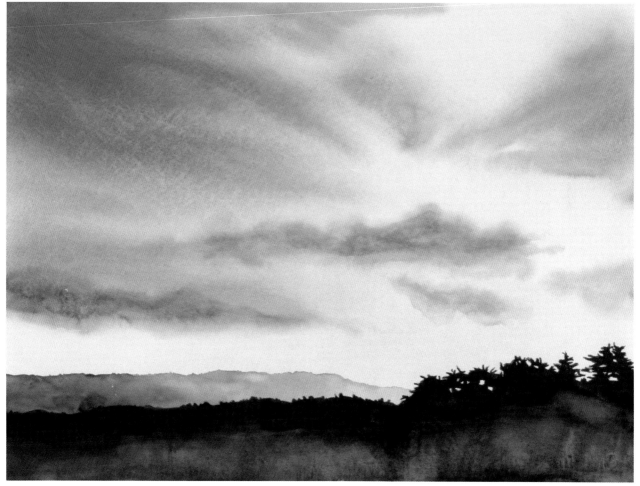

Texture Experiments

Using different textured papers can help with painting effects.

morning sunrise
watercolor on 300-lb. (640gsm) cold-pressed paper
22" × 30" (56cm × 76cm)

fog, valley mist & rain

Fog sometimes obscures and softens the landscape in the early morning and along the coast. Foggy mist may also fill valleys, leaving only the mountain tops peaking out. And rain can be anywhere, washing out colors and details. The combination of hard and soft edges is very effective when painting fog and rain.

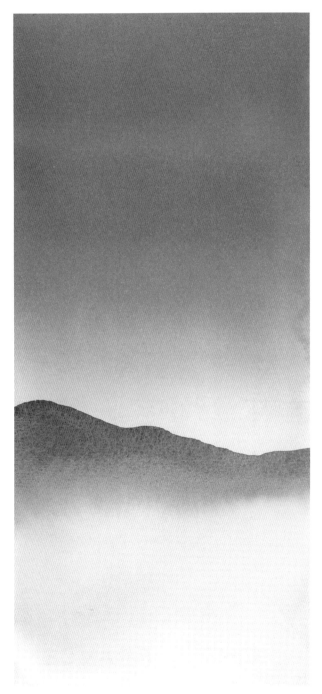

1 Create a Ridgeline

Create the background with a wash of color. Let dry. Using a no. 14 or no. 20 sable/synthetic blend round, apply color to the ridgeline.

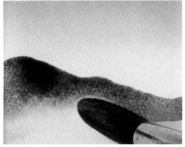 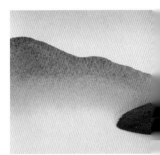

2 Soften the Color

While the color is still wet, use a clean damp no. 30 natural-hair or sable/synthetic blend round to soften the bottom edge. Using a larger brush helps to pull the color out without creating unintentional backwashes.

Rain

Make sure you've applied enough water to the paper so that the color will be able to move easily. To make rain, hold the paper at an angle and direct the flow. For a softer appearance, continue to move the paper to blend color more.

masking

The easiest way to reserve the white of the paper is to mask areas before applying color. Fluids such as frisket, masking fluid and molding paste are best for creating details. Paper towels, frisket paper, newspaper or contact paper work well to preserve larger areas.

APPLYING MASKING FLUID WITH A BRUSH

Never use your good brushes to apply masking fluid. Use an old brush designated specifically for masking fluid or use an Incredible Nib. To preserve the tip of the brush as much as possible, first dip the tip into a solution of a mild liquid detergent and water to coat the bristles. When you're finished, rinse the brush out with clean water. If the masking does dry in the brush, try a solvent such as Goo Gone to remove the dried masking.

GENERAL ADVICE

Do not use old liquid, leave fluid on a painting for too long, place the painting directly in the sun, or apply heat with a hair dryer. Some manufacturers do not recommend applying masking liquid to damp paper because the fluid could potentially bond with the paper, making it permanent and impossible to remove. (I personally have not had this problem and love the effect.)

Permanent masking fluid is also available and is *not* removable. The fluid bonds with the paper. Make sure the bottle you purchase says "removable" masking fluid.

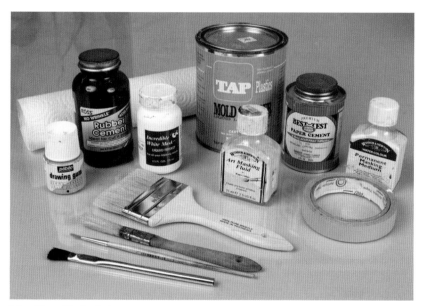

Brush Preparation
Dip the brush into a solution of mild soapy water before applying masking to help preserve the brush hairs. Rinse in clean water when you're finished.

Masking Materials
Molding paste, masking fluid, rubber cement, drawing gum, frisket contact paper, disposable brushes.

Tape
For angular designs and sharp lines, use artist's tape. Apply the tape to dry paper, press firmly along the edges to prevent color from seeping under the tape, then apply a wash of color. Once dry, remove the tape. Fill the reserved areas with color, apply another wash or leave it white.

MASKING WITH FLUID

MATERIALS

SURFACE

140-lb. (300gsm) cold-pressed paper

BRUSHES

disposable brush, large wash brush

PIGMENTS

any colors of your choice

OTHER SUPPLIES

masking fluid

Making fluid is an easy way to reserve the white of the paper while applying a wash of color.

Another Application Option

Instead of using a brush to apply masking fluid, try the Incredible Nib. This reusable tool looks like a pen with a feltlike nib on each end (one wide and the other pointed). After you've finished applying the masking fluid, allow the nibs to dry and pull the excess masking off.

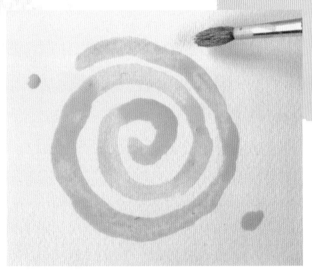

1 APPLY MASKING FLUID

Use an old brush or the Incredible Nib to apply masking to dry paper.

2 APPLY COLOR

Wait until the masking fluid is tacky (not sticky) before applying color. Sticky masking fluid can ruin your good brushes.

3 REMOVE THE MASKING FLUID

To remove the dried masking fluid, use the tips of your finger or a rubber eraser.

MASKING WITH CONTACT/FRISKET PAPER

To reserve areas or shapes such as a house, consider inexpensive contact paper available through hardware and grocery store or frisket paper available through art suppliers.

MATERIALS

SURFACE
140-lb. (300gsm) cold-pressed paper

BRUSH
large wash brush

PIGMENTS
any colors of your choice

OTHER SUPPLIES
contact or frisket paper, craft knife

MASKING

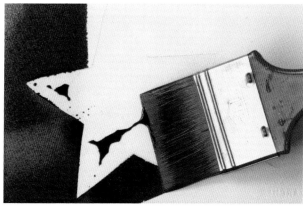

1 APPLY THE PAPER AND CUT OUT DESIGN
Apply contact or frisket paper to your surface, then lightly cut out your design with a craft knife (don't cut too deep—just score the film).

2 PAINT OVER THE DESIGN
Remove the excess paper, press the edges firmly to prevent the color from traveling under the film and apply a wash of color. Let dry.

3 REMOVE THE PAPER
Once dry, gently lift the film to remove and reveal the white of the paper.

MASKING WITH MOLDING PASTE

MATERIALS

SURFACE
300-lb. (640gsm) cold-pressed paper

BRUSHES
disposable brush, no. 20 sable/synthetic blend round, no. 30 natural-hair round

PIGMENTS
Indathrene Blue, Permanent Sap Green, Yellow Ochre

OTHER SUPPLIES
leaves, molding paste or rubber cement, rubber gloves, rubber eraser

Apply molding paste or rubber cement to the paper to create interesting effects. These substances are very thick and work well for creating texture in backgrounds. You can apply the paste to an object with an interesting texture, such as a leaf, to use as a stamp to place the molding paste.

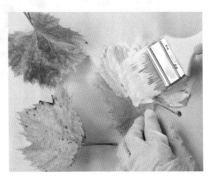

1 CREATE A DESIGN
Wearing rubber gloves, apply paste to an object with texture such as a leaf, rib-side down.

2 PRESS TO PAPER
Press the object masking-side down to the paper.

3 REMOVE AND REAPPLY
Reuse the leaf by reapplying molding paste or rubber cement as needed to create the design.

4 APPLY COLOR
Once the paste is dry, apply color as needed. Let dry.

5 REVEAL
After the color has dried, remove dried molding paste with your fingers or a rubber eraser. Fill areas with color or leave them white.

Safety Tip
When working with molding paste or rubber cement, make sure that your area is well ventilated. Read the label for more specific safety information.

Finished Painting
You can keep it simple by filling the white spaces with color, adding details as needed. Use this technique to create an entire painting or just a portion of it.

MASKING WITH PAPER DOILIES

Masking with lace or doilies is a quick way to create a lacy pattern. Depending on how you apply the color, the outcome will vary. You can create a semi-realistic depiction of lace or a more abstracted pattern.

MATERIALS

SURFACE
300-lb. (640gsm) cold-pressed paper

BRUSH
old toothbrush

PIGMENTS
Choose any colors you like.

OTHER SUPPLIES
paper doily

MASKING

1 APPLY DOILY AND SPLATTER COLOR
Lay the doily over the paper and begin spattering color (see page 76). Paper doilies work beautifully for lacy effects with clean lines.

 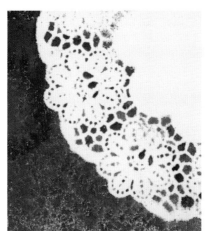 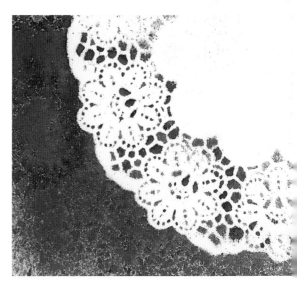

2 CONTINUE APPLYING COLOR
Continue spattering color over the doily. Create a gradual transition from one color to the next. Let dry.

3 REMOVE THE DOILY
Remove the doily to reveal the design.

4 ADD DETAILS
Add details as needed to develop the painting.

MATERIALS

SURFACE

300-lb. (640gsm) cold-pressed paper

BRUSH

no. 20 sable/synthetic blend

PIGMENTS

any color you choose

OTHER SUPPLIES

lace fabric, masking fluid, toothbrush, splatter screen or atomizer

Try brushing and spattering color through lace to create different effects.

LACE—ABSTRACT EFFECT

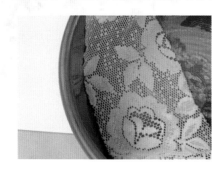

1 APPLY LIQUID MASKING
To prevent the fabric from soaking in too much color, apply a coat of liquid masking to the cloth first. Let dry.

2 APPLY PAINT
Place the lace on the paper, then apply color with a no. 20 sable/synthetic blend round. The brush holds plenty of water and easily fills the nooks and crannies. This can eliminate many of the finer details, leaving an interesting abstract effect.

3 REMOVE THE LACE
Remove the lace to reveal the abstract design.

LACE—DETAILED EFFECT

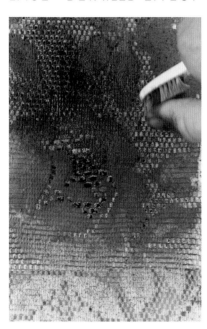
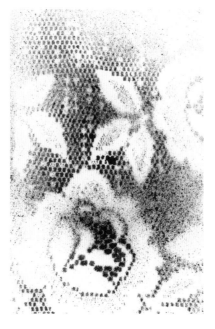

1 SPATTER THE PAINT
For a lacier, cleaner image, try spattering the color with a tooth-brush, splatter screen or atomizer (see page 76).

2 REMOVE THE LACE
This lighter application of color is less likely to seep under the lace, resulting in a cleaner, more detailed image.

To give the impression of dappled light on water, use masking fluid to reserve the white of the paper. Use cool blues for a moonlit scene or warm oranges for a sunlit scene.

MATERIALS

SURFACE
300-lb. (640gsm) cold-pressed paper

BRUSHES
scrub brush, no. 20 sable/
synthetic blend

PIGMENTS
French Ultramarine Blue, Indigo

OTHER SUPPLIES
masking fluid, rubber eraser

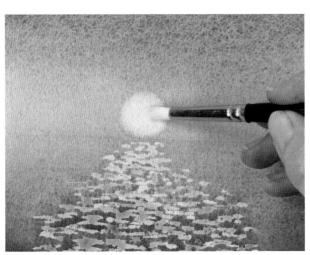

1 APPLY THE MASKING
Apply masking for the dappled moonlight on the water. Let dry. Apply the color wash and let dry.

2 BRING OUT THE MOON
Use a scrub brush to lift color, creating the moon.

3 REMOVE THE MASKING FLUID
Remove the rest of the masking fluid with your fingers or a rubber eraser to reveal the dappled light on the water.

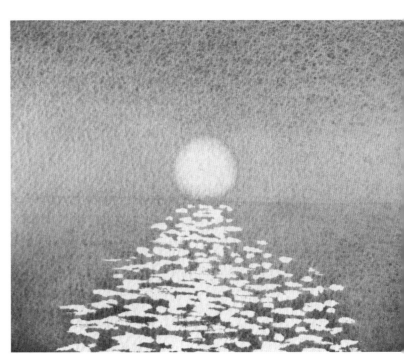

spattering

Spattering is a wonderful technique that can be used to give the impression of pebbles, sand, flowers, snow, ocean spray, and more. Spattering can help break up the sameness of a color or a large area. It can add that little extra something and accent areas, providing just enough detail without overworking. The spattering effect will depend on the size of the brush, the angle you hold it and any other tools you use.

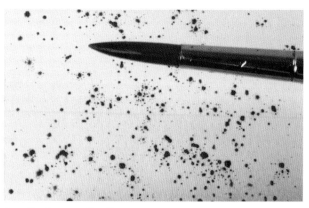

Spattering on Dry Paper

Spattering color on dry paper creates a more distinctive, deliberate effect. The size of the brush used determines the size of the droplets. This works well for areas where you want to suggest more detail, such as for pebbles, flowers or sand.

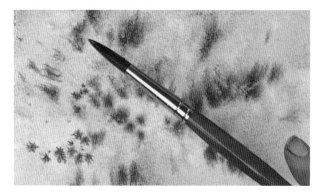

Wet-Into-Wet Spattering

Spattering color on a wet or damp paper creates a softer appearance that can suggest flowers, mosses or lichen on wood or rocks. The direction you hold the paper can help the impression of movement.

Spattering With Clean Water

Spattering clean water on drying color creates backwashes and blossoming. After you have applied color and the glisten has left the surface, spatter clean water. The results are similar to the effects of applying salt (see page 82), but this technique is faster and less messy.

Spatter Screens

For more evenly sized spatter, use a spatter screen. Screens used for cooking are available through grocery or hardware stores or smaller screens through art suppliers. Hold the screen close to the painting. The spatter will pass through the screen, creating an even texture.

Add Texture and Shape

While this simple pear shape was drying, I spattered both color and clean water to create more texture and clarify the shape.

SPATTERING WITH A TOOTHBRUSH

A toothbrush works well for creating a fine spray. It can be messy, so wear gloves to protect your fingers and nails. Dip the tip of the brush into the color. Then, holding the bristle side towards the paper, drag your thumbnail along the bristles. This technique is effective for creating sand and pebbles.

Using the toothbrush technique and masking, apply layers of color to create an authentic sand appearance.

MATERIALS

SURFACE
300-lb. (640gsm) cold-pressed paper

PIGMENTS
Burnt Sienna, Burnt Umber, French Ultramarine Blue

OTHER SUPPLIES
masking fluid, toothbrush, rubber eraser

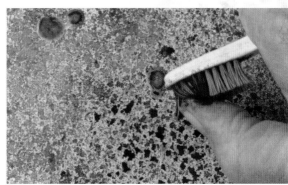

1 SPATTER MASKING
Use an old toothbrush to spatter masking and allow it to dry.

2 ADD COLOR
Spatter different colors to build layers.

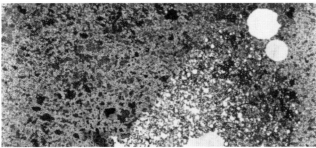

3 REMOVE MASKING
Once dry, remove the masking with your fingers or a rubber eraser to reveal the sand texture. To tone down the stark white of the paper, spatter color again. Use any larger areas or blobs of white to your advantage by turning them into stones.

Spattered Sand
To make authentic-looking sand, try spattering masking and layers of color.

low tide—mussel shell
watercolor on 300-lb. (640gsm) cold-pressed paper
22" x 15" (56cm x 38cm)

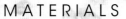

SPATTERING ON DAMP PAPER

MATERIALS

SURFACE

300-lb. (640gsm) cold-pressed paper

BRUSHES

no. 20 sable/synthetic blend round, toothbrush

PIGMENTS

any colors you choose

OTHER SUPPLIES

drawing gum, rubber eraser

Applying masking to damp paper creates some very interesting effects that add texture to a painting. It works beautifully for creating the impression of moss or lichen. Some manufacturers do not recommend applying masking fluid to damp paper. Personally, I have never had any problems doing so, and I love the effect it creates. I find Pebeo Drawing Gum works very well for this technique.

1 SPATTER DRAWING GUM
Do a wash of color or dampen the paper, and, while it is still damp, use an old toothbrush to spatter the drawing gum. Spattering drawing gum on damp color has a more diffused effect. Some brands of masking frisket may not be as effective as the drawing gum.

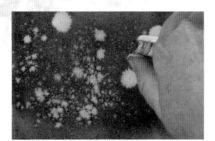

Textured Rocks

Applying drawing gum to damp paper and layering color creates some very interesting textural effects.

2 WASH WITH COLOR
Once the drawing gum is dry, build layers of color with washes or spattering. Once dry, remove the drawing gum with a rubber eraser or the tips of your fingers. Consider this technique for texture on rocks, walls and buildings.

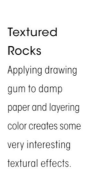

from the shore
watercolor on 300-lb. (640gsm) cold-pressed paper
12" × 5" (30cm × 13cm)

spattering with an atomizer

For the finest mist and most even spray, try using an atomizer. An atomizer is a device used to convert paint to a fine spray.

MOUTH ATOMIZER

This device has two tubes: place the shorter one into the liquid to be sprayed and blow into the other longer tube. Blow only. *Do not inhale.* The pressure of your breath draws the liquid up the other tube and propels it out onto the surface. Learning how to use an atomizer is just a matter of practice.

AEROSOL PROPELLANTS

If you feel that it is too hard to blow and that you are starting to turn blue, try a can of aerosol propellant (used for cleaning computers or cameras). These can provide the necessary force to blow through the tube, making it much easier. Simply place the tube attachment from the propellant into the longer tube end of the atomizer (where your mouth would blow) and let the compressed air do all the work.

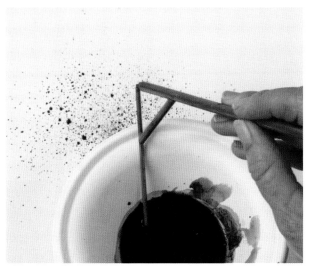

Atomizer in Action

An atomizer has two tubes. The smaller one is placed in the color while you blow through the larger one to create a fine mist.

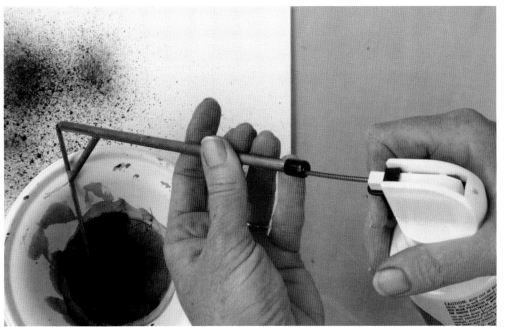

Using a Propellant

Instead of turning blue from blowing too hard, try a propellant used for cleaning cameras and computers. Insert the propellant tube into the longer atomizer tube and press the trigger.

MATERIALS

SURFACE

300-lb. (640gsm) cold-pressed paper

BRUSHES

nos. 8, 20 sable/synthetic blend rounds, no. 30 natural-hair round

PIGMENTS

French Ultramarine Blue, Indigo

Be creative. Turn the paper upside down and then back upright to make uneven lines that create the impression of waves or rocks.

1 TURN THE PAPER UPSIDE DOWN

Turn the paper upside down, then paint a wave. Holding the brush at a perpendicular angle to the paper creates a rougher drag-edge line. This makes a more natural-looking wave.

2 RIGHT SIDE UP AGAIN

Turn the paper right side up to reveal the uneven edge line. Continue changing the angle of the brush, using different values to make the waves.

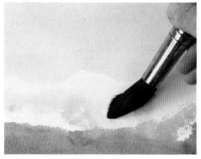

3 SOFTEN EDGES

Use a no. 30 natural-hair round to soften the edges and hard lines to create the effect you want.

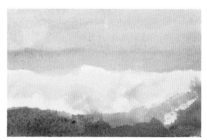

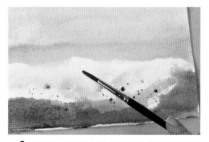

4 ADD SPRAY WITH SPATTER

Using a no. 8 sable/synthetic blend round, spatter a little paint to create an ocean spray effect.

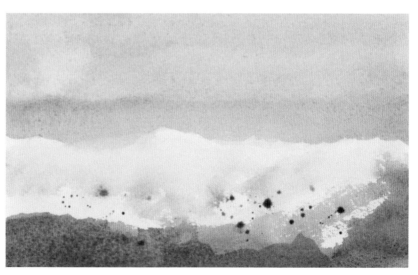

When waves crash, the ocean spray can lift into the wind, creating this exciting effect. Apply masking fluid or drawing gum with a toothbrush before you start painting.

MATERIALS

SURFACE
300-lb. (640gsm) cold-pressed paper

BRUSHES
no. 20 sable/synthetic blend round,
no. 30 natural-hair round

PIGMENTS
French Ultramarine Blue, Indigo

OTHER SUPPLIES
masking fluid, rubber eraser,
toothbrush

1 MASK WITH A TOOTHBRUSH
Use a toothbrush to spatter masking in areas that will be the most active. Let dry.

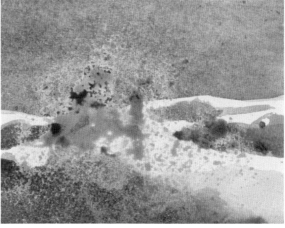

2 APPLY COLOR
Apply color to create the sky and waves. Let dry.

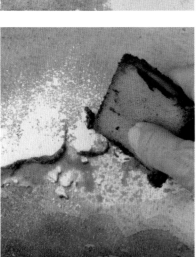

3 REMOVE THE MASKING
Remove the masking fluid with your fingers or a rubber eraser to reveal the ocean spray.

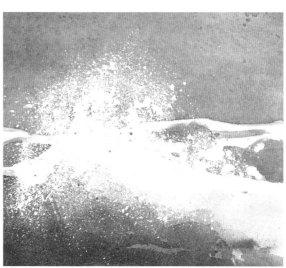

salt

Try sand, salt and other natural minerals, all of which will create interesting effects in the drying color.

Salt is a standard technique used to create texture in a drying wash. This effect works well in landscapes to break up the "sameness" of large areas or to create snow. It also works well in the background of still lifes and florals.

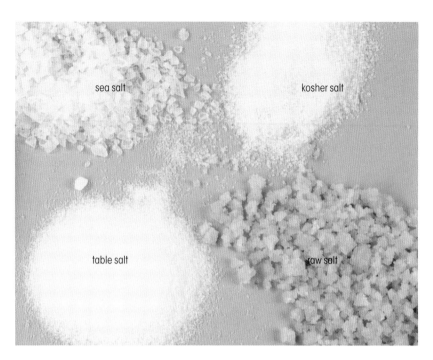

sea salt

kosher salt

table salt

raw salt

Salt Variations

There are many different types and sizes of salt, including raw, sea, rock, table and kosher. Each has a slightly different effect.

Applying Salt

Apply a wash of color. After the glisten has left the surface, sprinkle on salt crystals and let the wash dry. The crystals will start to absorb the surrounding color, changing the texture. If the surface is too wet, smaller crystals may dissolve too quickly and not leave much effect. For the best results, use a damp matte surface.

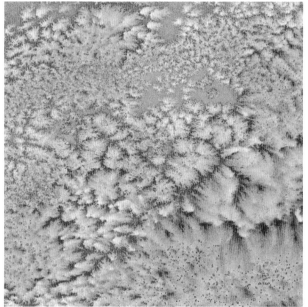

Remove the Crystals

Once the paint is dry, shake off the salt to see the design.

sand

For a different textural effect, try sand. The fine particles of wet sand hold together more, and the minerals and salt give different effects. It's great for abstracted paintings, landscapes or still lifes. Try both wet and dry sand for different effects.

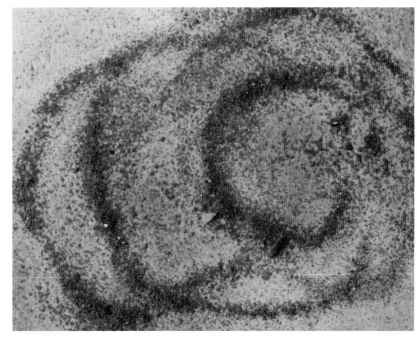

Dry Sand

You have more control in applying dry sand. You can sprinkle it evenly or form it into deliberate designs. Once dry, shake off the sand.

Wet Sand

Wet sand clumps more than dry sand, allowing the minerals present in the sand to effect the color and create random designs. Once dry, shake off the sand.

Painting with watercolor is all about having fun and experimenting. Try incorporating common household products to create interesting effects in your paintings.

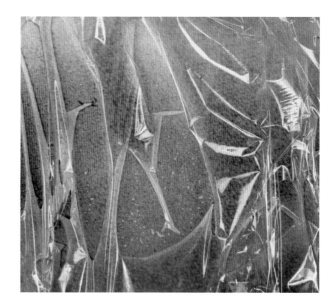

Plastic Wrap

Plastic wrap works well for creating trees or rocky outcroppings. Place plastic wrap over a wash of color and allow it to dry. The trapped air will change the surface, creating angular shapes. Try using this technique in an underpainting, or apply it in layers or in select areas.

Reveal the Patterns and Texture

Once dry, remove the plastic wrap. The design it creates is suggestive of trees, rocks or ice crystals.

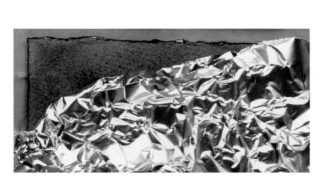

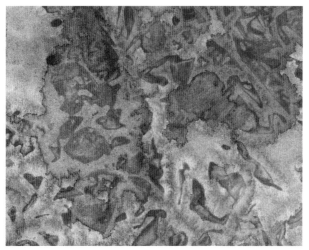

Foil and Wax Paper

Aluminum foil (left) and wax paper (right) create effects similar to those made by plastic wrap. Just about anything pressed firmly onto drying paint will create different designs and textures.

Plastic wrap isn't just for covering bowls. Try applying it to drying color. The air pockets will create designs that can be used in abstracts or incorporated into portions of a painting to give the impression of rocks or trees.

MATERIALS

SURFACE
300-lb. (640gsm) cold-pressed paper

BRUSHES
nos. 8, 14, 20 sable/synthetic blend rounds, wash brush

PIGMENTS
Burnt Umber, French Ultramarine Blue, Permanent Alizarin Crimson, Permanent Sap Green

OTHER SUPPLIES
plastic wrap

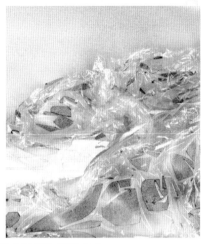

2 REMOVE THE WRAP
Once dry, remove the plastic wrap to reveal the shapes.

1 PAINT AND COVER WITH PLASTIC WRAP
Create your initial design. While the washes are still damp, apply plastic wrap in limited areas. The air pockets will help create texture and design.

3 ADD DETAILS AND CONTRAST
Using the abstracted shapes, pull out your design and enhance the finer details.

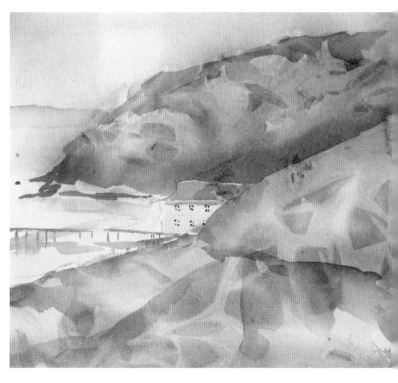

NEGATIVE PAINTING

MATERIALS

SURFACE

140-lb. (300gsm) cold-pressed paper

BRUSHES

no. 30 natural-hair round or wash brush, nos. 14, 20 sable/synthetic blend rounds

PIGMENTS

any colors you choose

Pulling shapes out of negative space subtly suggests the presence of an object without overworking the painting. You can use this technique to create an entire painting or for limited areas such as to suggest foliage or trees in a background. This method may create a flatter surface, but it is still a good technique to keep in your arsenal.

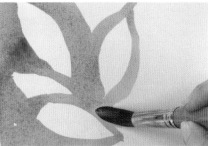
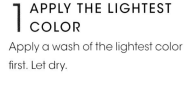

1 APPLY THE LIGHTEST COLOR

Apply a wash of the lightest color first. Let dry.

2 PAINT AROUND THE SHAPES
Paint around the lightest forms and shapes with a darker value or color. Let dry.

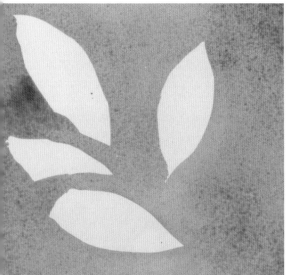

3 DEEPEN THE VALUE AND DETAIL
Continue using the same process, darkening the value and adding more shapes and detail.

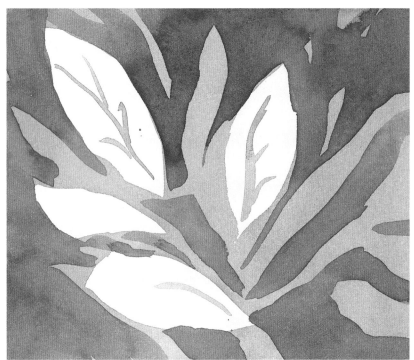

CANDLE WAX & CRAYONS

Candles and crayons act as a resist. For wood on barns, walls or rocks, mark directly on the surface to catch the tooth of the paper. Or you can use an iron to melt the wax for more abstracted effects. When melted, the wax bonds with the paper to create a permanent effect.

MATERIALS

SURFACE
140-lb. (300gsm) cold-pressed paper

BRUSH
no. 20 sable/synthetic blend round

PIGMENTS
any colors you choose

OTHER SUPPLIES
candle, kitchen grater, iron, wax paper

UNMELTED CANDLE OR CRAYON

1 APPLY THE WAX
Using a candle or a crayon, rub the surface to catch the tooth of the paper.

2 APPLY THE PAINT
Apply a wash of color.

3 CONTINUE PAINTING
Finish painting your composition. This technique works well for fence posts and other weathered wood surfaces.

MELTED CANDLE OR CRAYON

1 APPLY AND MELT THE WAX
Using a kitchen grater, shave wax from a candle and place the shavings on your paper. Next, place a sheet of wax paper over the shavings. Then, using an iron on a low heat, melt the wax. Depending on the effect you want, press straight down to keep wax in place or move the iron around to smear it. Let cool (for a second).

2 APPLY COLOR
Apply a wash of color over the wax. The wax will resist the paint, making for some interesting designs. This is great for abstracted paintings or to incorporate into a still life or landscapes.

Wax Possibilities
The wax is nonremovable, but you can try to scrape some off with a blade to create an interesting effect. This technique works very well for loose, abstracted still lifes.

MATERIALS

SURFACE

140-lb. (300gsm) cold-pressed paper

BRUSH

no. 20 sable/synthetic blend round

PIGMENTS

any colors you choose

OTHER SUPPLIES

crayons, pencil sharpener, iron, wax paper

For a more colorful form of wax, try using crayons. Use a few colors and see what happens. Instead of a grater, try a pencil sharpener. Crayon shavings are more brittle and can be incorporated nicely into paintings.

1 PLACE SHAVINGS

Use a pencil sharpener to create crayon shavings. Place the shavings on top of the watercolor paper.

2 MELT THE WAX

Place a sheet of wax paper over the shavings, then use an iron on a low heat setting to melt the crayon.

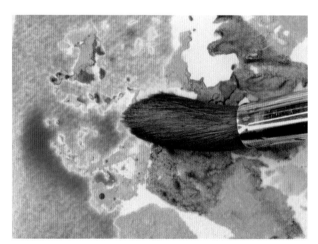

3 APPLY A WASH OF COLOR

Allow the wax to cool for a few seconds so that the wax won't bond with the brush fibers, then apply a wash of color. The crayon resists the color, creating an interesting effect that works very well for some landscapes and other compositions.

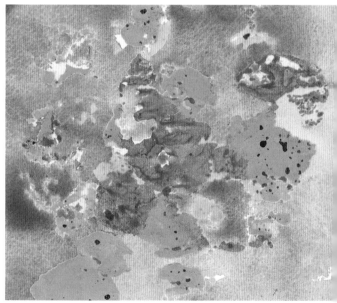

Crayon Composition

Create a playful composition using crayons, then wash over it with different colors.

scratching, sanding & scoring

You can change the texture of the paper by intentionally damaging the surface. Once a wash of color has been applied and dries, use a craft knife, razor blade, knife or even sandpaper to scratch the surface to reveal the white of the paper. This technique works in any area that needs more texture.

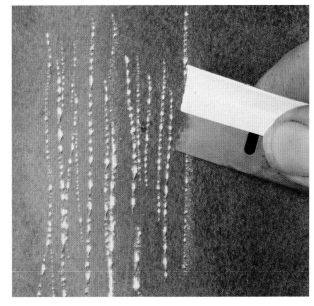

Scratching

Use a craft knife or razor blade to scratch a dried painted surface to reveal the white of the paper. This works well for creating the texture of wood and rocks.

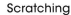

Score the Paper

An easy way to give the impression of veins, grasses or details on trees is to score the paper. Use the handle of a paintbrush or a butter or palette knife, or try a knitting needle or crochet hook. While the color is still wet, lightly score the paper to impress a design, then watch as the pigment settles back into the grooves, leaving smooth imprinted lines.

Sandpaper

Rub sandpaper over dried color. The sandpaper lifts and removes the highest areas of the surface texture, revealing the white of the paper. Color in the deeper grooves and wells of the surface is left behind. Try using different grits for variations of this effect.

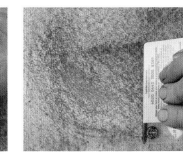

Credit Card

Running an old credit card over wet color damages the surface, creating wonderful textural effects for walls, rocks, wood or any other roughly textured surface. The card damages the surface, then, as the color settles back, texture appears. This technique works best on cold-pressed or rough paper.

creating designs with straws

This technique is all about having fun. In fact, I'm sure you've probably tried this technique as a child. Simply blow through a straw to create random effects or direct the flow to give the impression of vegetation in a landscape.

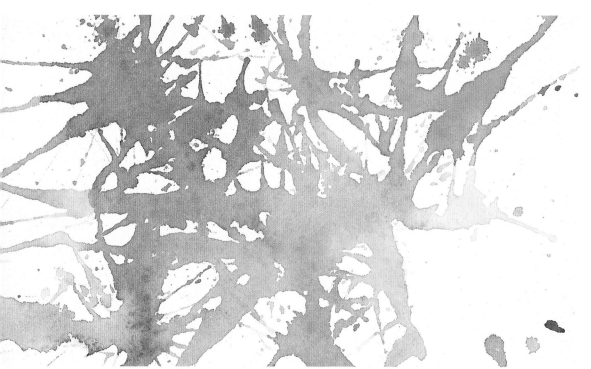

Create Random Designs

Drop some color onto the paper, then blow through the straw on the paint. Blowing straight down can make the paint explode out from the center in all directions.

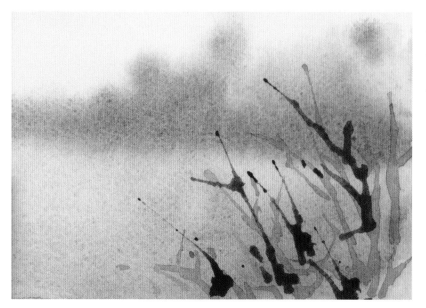

Direct the Flow

To direct where the paint goes, change the angle of the straw and blow, guiding the paint however you want it. This technique works very well for natural looking reeds for landscapes.

staining

Use a pot of leftover tea or coffee or the actual grounds or leaves to stain paper. Paint can also be used as a stain (see the *Batik Effect* below). All of these techniques can be used to add texture or to tint the paper as an underpainting.

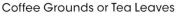

Coffee Grounds or Tea Leaves

Coffee grounds or tea leaves work well for staining paper. Sprinkle them onto damp color to create texture for rocks or sand.

Tint With Tea or Coffee

Instead of brushing color to tint paper, try dipping the paper in a bath of leftover tea or coffee. Fill a tub or container with the leftover coffee or tea and add enough water to cover the paper. Add more coffee or tea for a stronger solution. Dip the paper into the tub to tint it. The strength of the tinting will be determined by how long you submerge the paper. The longer the time, the darker the color.

Batik Effect

Batik is a wax-resist technique used for dyeing textiles. You can create similar effects on your paper with paint. Crumple wet paper, then apply color. The damaged surface creates a batik effect when color is added. Use as an underpainting and paint a composition over it. If you want a smoother surface, iron the back on low heat.

marbling

Marbling dates back to twelfth century Japan. This technique was termed *suminagashi*, or "floating ink." During the fifteenth century another type of marbling originated in Turkey. It was dubbed *ebru*, or "cloud art." Marbling spread to Europe during the sixteenth and seventeenth centuries. These techniques were kept as trade secrets by a handful of people, but today thousands know the secrets of marbling and this wonderful form of expression.

REMOVE THE SIZING OF THE PAPER

First remove the paper's sizing so that it will better absorb the floating color. Otherwise, the pattern will appear more like blobs than a design.

Soak the watercolor paper in clean water or in a bath of alum and water (2 tablespoons alum [15ml] to 1 gallon [4l] of water) to remove the sizing. Alum is available at some drug stores or where fabric dyes are sold and will make any organic surface absorbent. After soaking, rinse with clean water to remove any residue of the alum (alum can degrade the paper).

Rice paper or blotting paper works well because it isn't sized, so there's no need to soak it first. But these papers react differently from watercolor paper. Do not use student-grade watercolor paper since the surface is not as absorbent.

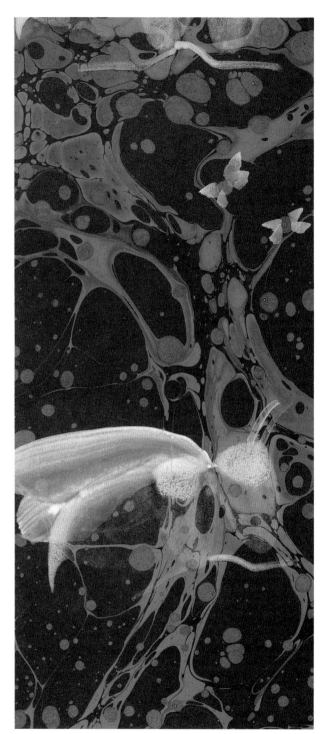

Marbled Art

Marbled paper is an art in its own right, but you can also use it for the basis of a painting. My friend Ingrid Butler of Moth Marblers created this beautiful marbled paper.

92

The marbling technique works well for patterns in rocks or to create the impression of moving water. Consider using this technique for a foundation to your paintings or limit the marbled area by masking first.

MATERIALS

SURFACE
*140-lb. (300gsm) cold-pressed paper
(or try rice or blotting paper)*

BRUSH
*no. 20 round sable/synthetic blend
or sumi brush*

OTHER SUPPLIES
*tub to soak paper, alum, sumi ink,
colored ink, ox gall liquid*

1 FLOAT THE COLOR

Remove the sizing and allow the paper to dry, or use rice or blotting paper. Spray the back with clean water to make it more pliable. Float ink on the surface of a tub of water. (Inks float the best. Most watercolors sink too quickly. If using watercolor, choose lighter colors or add a little ox gall liquid to help keep the color floating.)

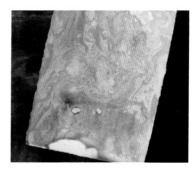

2 DIP LIGHTLY

Gently roll the paper on the surface of the water to pick up the ink.

3 CREATE RANDOM DESIGNS

Use the organic designs to your advantage. Here you can see how marbling could be used in rocks or other organic subjects.

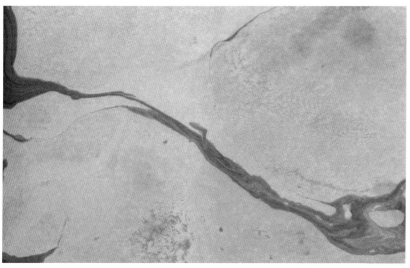

MONOPRINTING

MATERIALS

SURFACE

140-lb. (300gsm) cold-pressed paper

BRUSH

no. 20 sable/synthetic blend round

PIGMENTS

any colors of your chose

OTHER SUPPLIES

acrylic sheet (Plexiglas), brayer

This monoprinting technique is similar to marbling, except you press the paper onto a surface covered with paint. In monoprinting, the image on the paper is the opposite of the paint design on the surface. Use this technique on its own, or incorporate it into your design.

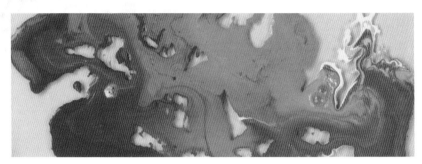

1 APPLY COLOR

Apply color to a nonabsorbent surface such as Plexiglas or a tabletop.

2 FLATTEN THE PAPER

Place the paper on top of the color, then use your hands or a brayer to flatten the paper onto the surface.

3 REVEAL

Lift the paper to see the design.

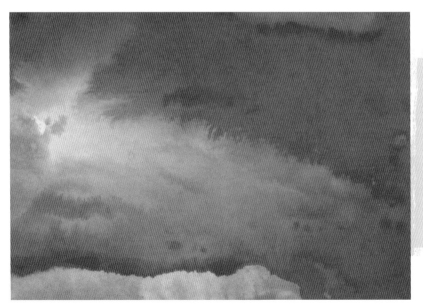

Tip

For a little more control over the color, reduce the slickness of the Plexiglas surface by cleaning it with an abrasive cleanser first. Rinse and dry the surface, then apply color.

Consider adding other elements to your paintings to make them even more interesting. The gold leaf technique works great for still lifes and landscapes or just to add that little extra something.

Gold leaf is delicate and crumbles easily. It's sold in single-sheet booklets. Complete your painting first, then apply the gold leaf.

MATERIALS

SURFACE

140-lb. (300gsm) or 300-lb. (640gsm)
cold-pressed paper

BRUSHES

disposable brush, hake brush

OTHER SUPPLIES

gold leaf, gold leaf glue, gold leaf seal

1 PREPARE THE SURFACE
Using a disposable brush, apply gold leaf glue, which is specifically made for applying gold leaf, to the finished painting (apply only to areas you wish to cover with leaf).

2 APPLY THE GOLD LEAF
Allow the glue to get tacky first, then place the leaf on the area and press gently. Press the leaf to the surface with a soft brush or for a more aggressive application use a stiffer brush to remove the excess.

3 USE A SEALER
Once dry, seal the gold leaf with gold leaf sealer. This will permanently bond the gold leaf with the painting so that it will no longer flake off.

mediums

Change the effect of the watercolor by adding different mediums to the paint or water. Mediums can add texture or create areas of interest, making paintings more vibrant or interesting.

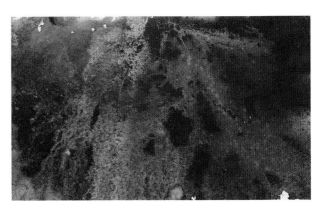

Granulating Medium

Granulating medium creates a mottled effect in an otherwise smooth wash. It adds dimension and makes for some very interesting areas. For a more dramatic effect, try rough paper and sedimentary colors, which have a tendency to granulate. These colors include French Ultramarine Blue, Burnt Umber, Burnt Sienna, Rose Madder Genuine, Cobalt Blue, Cobalt Green, Ultramarine Violet, Manganese Blue Hue, Raw Umber and Viridian.

Texture Medium

Fine particles in this medium help create depth and texture. Use this to build layers, suggest structure or add to the texture of sand, trees and buildings.

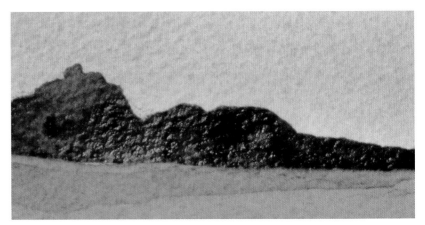

Gum Arabic

Adding gum arabic to the water (1:2 ratio) will increase the transparency and add a glossy sheen to colors. Avoid applying the liquid too thickly or directly from the bottle. If you do, the pigment can become brittle and flake.

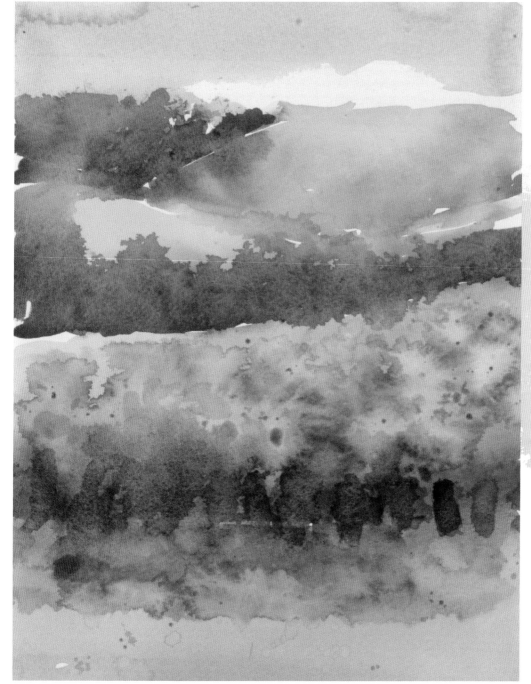

on the farm
watercolor on 90-lb. (190gsm) cold-pressed paper | 11" × 8½" (28cm × 22cm)

Ox Gall Liquid

Ox gall liquid is a wetting agent. Add a few drops to your water to increase the flow of color. If your paper is not taking a wash and continues to have small dots of white paper showing through, apply a wash of ox gall liquid to reduce the surface tension, then let it dry.

The addition of a little ox gall liquid allows watercolor to move more easily, changing the painting's texture. While the color is still damp, try spattering clean water. These intentional backwashes will give the impression of leaves in the foreground. Adding the tree line softens the edges, creating a more natural appearance.

MATERIALS

SURFACE

140-lb. (300gsm) cold-pressed paper

BRUSHES

*disposable brush, no. 20 sable/
synthetic blend round*

PIGMENTS

any colors you choose

OTHER SUPPLIES

rice paper, water-based glue

Rice paper can be used to create a three-dimensional quality in a painting. Many different kinds of beautiful rice papers are available, with different levels of transparency to choose from. Apply the rice paper and paint over it, or use in layers to show the underpainting. Have fun with it.

1 ADD RICE PAPER TO A PAINTING

Use an inexpensive disposable brush to apply a water-based glue such as Nori or Yes! Paste to the painting. Place the rice paper over the glue and allow it to dry before painting again. Flatten the surface or use the wrinkles to create more texture. A more transparent rice paper will allow you to see the layer of the underpainting.

2 PAINT OVER RICE PAPER

Once the rice paper has adhered to the watercolor paper, paint over it again to add color over the texture. Let dry.

Painting Possibilities

Use this technique to create abstract paintings or locate shapes to develop the painting into a still life, floral or landscape.

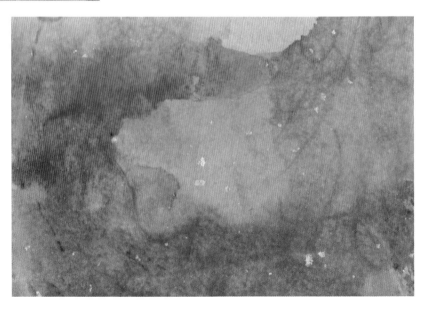

This is a very unusual way to create trees. Watch as the magic happens right before your eyes. Tree seal is a dressing used to seal wounds and cuts in trees. It is available at nurseries. Use only disposable brushes when painting with tree seal. Tree seal will act like a resist so watercolor is best used in areas where the tree seal has not been applied.

MATERIALS

SURFACE
140-lb. (300gsm) or 300-lb. (640gsm)
cold-pressed paper

OTHER SUPPLIES
tree seal, disposable container,
disposable brush

TREES

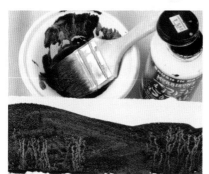

1 THIN SEAL WITH WATER
Mix tree seal with water in a disposable container. Using a disposable brush, apply the thinned tree seal to watercolor paper.

2 TILT THE PAPER
Tilt the paper and hold it at an angle, then watch as the magic happens. The tree seal runs and separates, creating an abstract tree pattern. Apply this technique over a completed watercolor painting, or, once dry, paint over the seal and on the remaining white areas. Tree seal is permanent and will not lift.

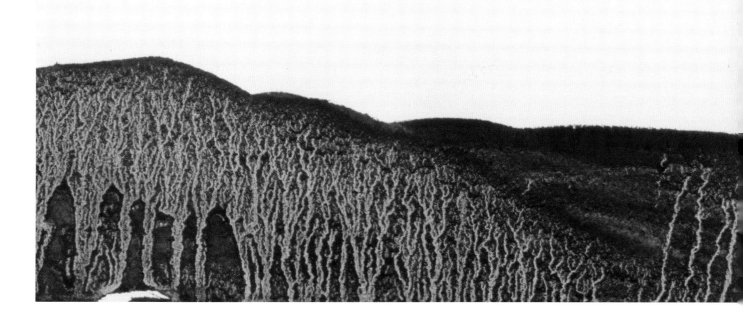

DIATOMACEOUS EARTH

MATERIALS

SUPPLIES
140-lb. (300gsm) cold-pressed paper

PIGMENTS
any colors you choose

OTHER SUPPLIES
diatomaceous earth powder, Elmer's Glue, bowl, disposable brush

Diatomaceous earth, a chalk-like powder made of sedimentary rock, can create another textural surface. It is wonderful for abstracted pieces that suggests stucco and rocks as well.

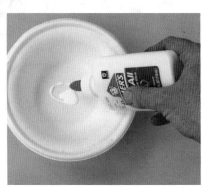

1 MIX GLUE WITH WATER
Mix Elmer's Glue with water (2:1 ratio).

2 BRUSH AND SPRINKLE
Apply the mixture to the paper with a disposable brush, then sprinkle on the diatomaceous earth. Shake off the excess powder and let dry.

3 WASH WITH COLOR
Once dry, add a layer of color.

Using natural sponges to apply color makes random designs, which work well for creating the impression of foliage.

MATERIALS

SURFACE
140-lb. (300gsm) cold-pressed paper

PIGMENTS
any colors you choose

OTHER SUPPLIES
natural sponge

1 APPLY PAINT
Dip a small natural sponge into color and press it onto the paper.

2 VARY THE PRESSURE
The harder you press, the more solid the color.

3 USE DIFFERENT VALUES
Apply different values to create depth.

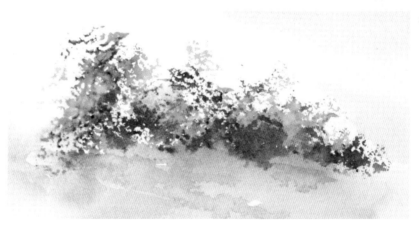

Layer Foliage
Use this technique to build layers of foliage in your landscapes.

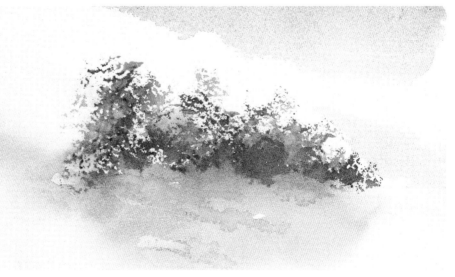

NATURAL FOUND OBJECTS

TREES

MATERIALS

SURFACE

140-lb. (300gsm) cold-pressed paper

BRUSH

no. 20 sable/synthetic blend round

PIGMENTS

Burnt Sienna, Burnt Umber, French Ultramarine Blue, Permanent Sap Green

OTHER SUPPLIES

moss, roots, grass or kelp, spray bottle

Go for a walk and see what you can find to use in your paintings: moss, grass, roots and kelp can all make organic-looking trees and bushes. Apply paint to your found object, then press it onto the paper. Use the stamped image as a guide for trees.

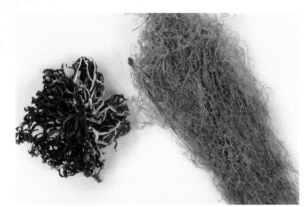

Roots and Moss

Use natural items such as this kelp holdfast from the beach and moss from the woods to apply color.

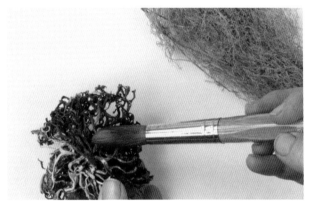

1 BRUSH WITH COLOR

Many roots, kelp holdfasts and mosses already look like little trees. Apply paint to the root, then press it to paper to create a tree trunk.

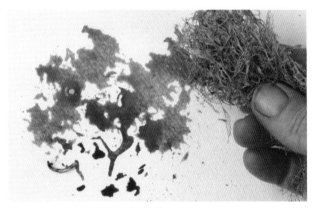

2 STAMP WITH MOSS

Use the same technique with the moss to create the foliage of the tree.

3 SPRAY THE EDGES

Soften the edges with a spray bottle to help create the impression of leaves.

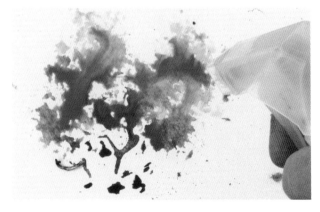

tree variations

Trees and bushes can be created by several different methods. You can use wet-into-wet techniques, deliberate brushstrokes, or even leaves or moss you find on a walk. Remember, you don't need much detail or it can look overworked. Keep the trees loose and simple, and let the viewer use his imagination.

Random Brushstrokes

For a less deliberate depiction of trees or bushes, dabble the colors to break up the space.

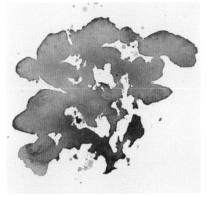

Brushstrokes and Foliage

Random brushstrokes create foliage that is very different from stamped foliage.

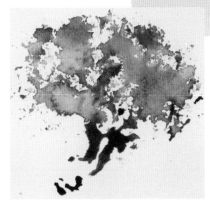

Backwash Branches

Backwashes can work to your advantage. Try using them to create the impression of layered branches. Stamp on the color and spray with water.

Pine Trees Using Brushstrokes

Starting with the center line or trunk, hold the brush loosely in your hand and create the size and width of the tree. Taper the branches as you reach the top.

Pine Trees Using Moss

Moss can create the impression of needles so that you don't have to paint each one.

Exotic Trees

The angular lines of flat brushes work well for exotic plants and trees. Lightly press the tip down and change the angle of the brush. Have fun. The harder you try, the more labored it will look.

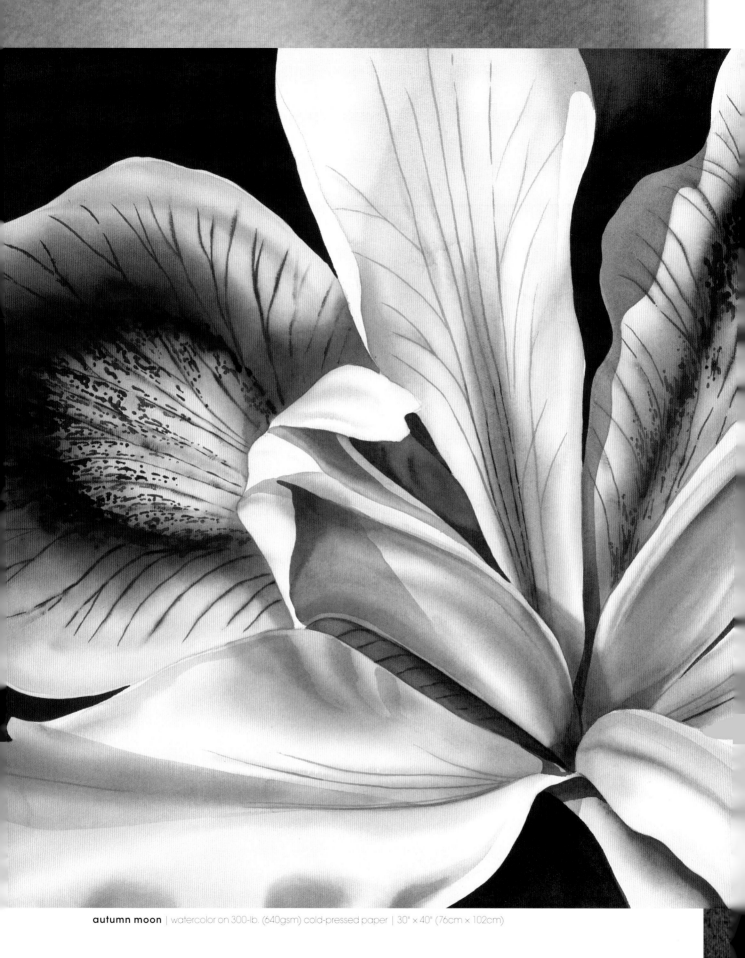

autumn moon | watercolor on 300-lb. (640gsm) cold-pressed paper | 30" × 40" (76cm × 102cm)

CHAPTER 5:
applying the techniques

Now we'll start to apply some of the techniques you've learned to paintings. Learn to use negative space, masking, wet-into-wet and wet-into-dry techniques in your compositions. Build color with luminous washes, add shadows and create depth. Don't forget to relax and have fun!

FLAT BRUSHES & NEGATIVE SPACE

MATERIALS

SURFACE

300-lb. (640gsm) cold-pressed paper

BRUSHES

nos. 20, 30 natural-hair round. large synthetic wash brush, 1-inch (25mm) flat

PIGMENTS

Burnt Sienna, Burnt Umber, French Ultramarine Blue, Indigo, New Gamboge, Permanent Alizarin Crimson, Permanent Sap Green, Quinacridone Magenta

OTHER MATERIALS

pencil

TECHNIQUES

- *high contrast (page 45)*
- *wet-into-wet (page 64)*
- *shadows (page 44)*
- *flat brushes (page 17)*
- *backwashes (page 38)*
- *spattering (page 76)*

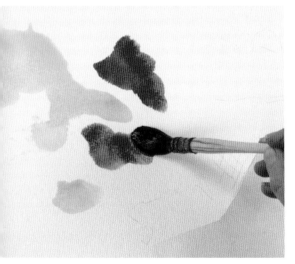

Flat brushes create angular strokes and shapes, which help define the sharp edges of negative space. Large wash brushes can cause backwashes and blossoming since the brush holds so much water. This can be a nice effect in loose paintings. Once you've applied the color, pull images and shapes out of the negative spaces.

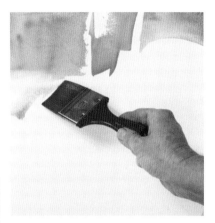

1 SKETCH

Paint around the outline of the chair and flower areas first since they will be defined as negative space. Using a large synthetic wash brush, apply a mixture of French Ultramarine Blue, Burnt Umber and Indigo to the background. It's all right to have blossoming color and bleeding. Keep it loose.

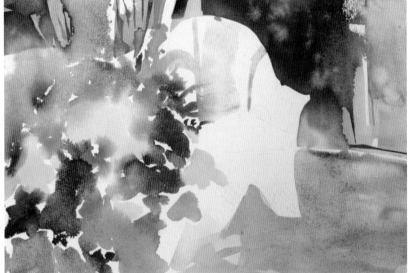

2 ADD THE FLOWERS AND FOLIAGE

Use a large no. 20 natural-hair round or small mop brush to fill the flower and foliage areas with random brushstrokes of Permanent Alizarin Crimson, Quinacridone Magenta, New Gamboge and Permanent Sap Green. Leave space around the strokes so that the edges barely touch and can blend without overmixing. Let dry.

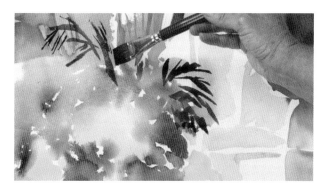

3 DEFINE SHAPES

Use a 1-inch (25mm) flat and a mixture of Permanent Sap Green and French Ultramarine Blue to start to define areas and pull the shapes of the flowers and plants. Change the angle of the brushstroke to create different plants.

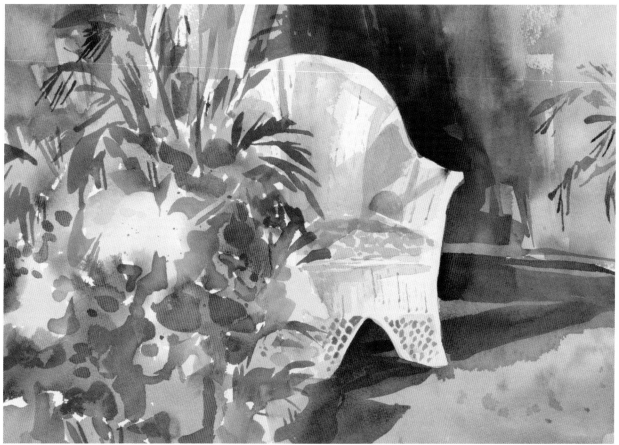

4 ADD SHADOWS AND DETAILS

Using the background colors in a lighter value, add shadows inside the chair. Deepen the value by adding Indigo. Use the 1-inch (25mm) flat to apply the mixture around the outside of the chair to create contrast and make the background more interesting. Using a mixture of Burnt Umber, Burnt Sienna and French Ultramarine Blue, paint in the floor. While the color is still damp, splatter in some of the background color to help unite and balance the painting. Then add more details and define shapes throughout the painting. For rounder shapes and flowers, use a no. 20 or no. 30 natural-hair round.

once upon a time
watercolor on 300-lb. (640gsm) cold-pressed paper
15" × 20" (38cm × 51cm)

MATERIALS

SURFACE
300-lb. (640gsm) cold-pressed paper

BRUSHES
no. 30 natural-hair round, nos. 8, 14, 20 sable/synthetic blend rounds

PIGMENTS
Burnt Sienna, Burnt Umber, Cyanine Blue, French Ultramarine Blue, Winsor Green, Yellow Ochre

OTHER MATERIALS
pencil, masking fluid

TECHNIQUES
- *masking (page 69)*
- *wet-into-wet (page 64)*
- *grasses (page 65)*
- *rocks (page 78)*
- *spattering (page 76)*

Using a combination of the same techniques you used in the previous demonstration, but using only round brushes instead of flat, you can create an entirely different feeling in the painting. It is still loose but with more of a realistic look.

1 SKETCH AND MASK
Sketch the image with a pencil. Then apply masking fluid to reserve the white of the paper for the finer details, including the rope, the foam on the water and the sand.

2 START WITH THE BACKGROUND
Use a no. 20 sable/synthetic blend round and a mixture of French Ultramarine Blue and Burnt Umber. With the wet-into-wet technique, paint in the water in the background over the dried masking and add the shadow to the side of the boat. Use a mixture of Burnt Sienna and Yellow Ochre to establish the shoreline grasses, and a mixture of French Ultramarine Blue and Burnt Umber to add the rocks and sand.

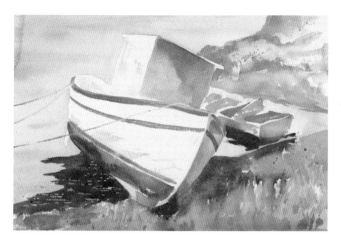

3 DARKEN THE VALUES

Using the previous layer as a guide, increase the color and darken the values with different sized brushstrokes (use nos. 8, 14 and 20 sable/synthetic blend rounds). Start adding details in the rocks and grasses by pulling images out of the negative space. Use the splattering and dry-brush techniques to add texture and detail.

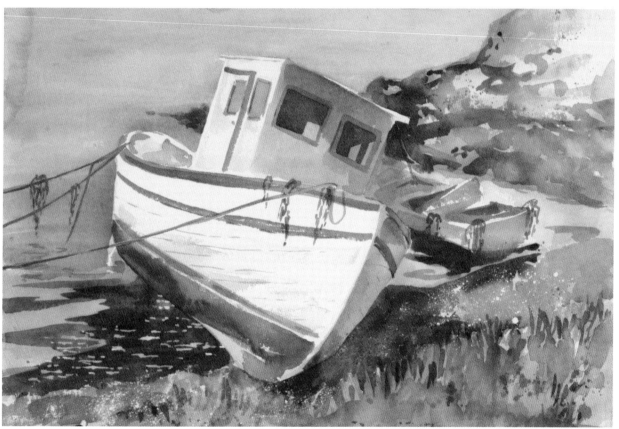

4 REMOVE THE MASKING AND ADD FINAL DETAILS

After the paint is dry, remove the masking, then paint details in the ropes and kelp. Using a mixture of Cyanine Blue and Winsor Green, create the impression of lapping waves under the boat with loose brushstrokes (see water demonstration on page 75). Add other details, including the windows. Leave portions of the windows unpainted, allowing the color underneath to show through. This gives the impression of looking out through the window into the background.

on shore
watercolor on 300-lb. (640gsm) cold-pressed paper | 15" × 22" (38cm × 56cm)

CAPTURING THE ESSENCE OF YOUR SUBJECT

MATERIALS

SURFACE

5" × 7" (13cm × 18cm) 300-lb. (640gsm) cold-pressed paper

BRUSHES

no. 30 natural-hair round, nos. 6, 8, 10 sable/synthetic blend rounds

PIGMENTS

Burnt Sienna, Burnt Umber, French Ultramarine Blue, Permanent Sap Green, Yellow Ochre

OTHER MATERIALS

pencil, tape

TECHNIQUES

wet-into-wet (page 64)
trees and hills (pages 97 and 102)
layering (page 30)
hard and soft edges (page 35)

If you tend to add too many details and overwork your paintings, try working small and loose. This will force you to paint only what's important. You'll eliminate many of the unnecessary details and capture the essence of your subject. This technique is very forgiving and works well for plein air painting.

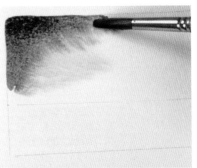

1 CREATE A BOUNDARY

First create a boundary so that you know how far to paint. This will help you avoid painting outside of the area you intend to paint. A boundary can be created with a pencil line, tape or the edge of the paper.

Create a 4" × 6" (10cm × 15cm) rectangle with a pencil, then apply water inside of the pencil line with a no. 30 natural-hair round. Leave a small, horizontal dry area near the center. This will be the shoreline.

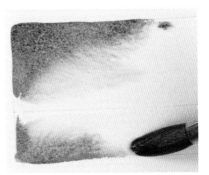

2 ADD COLOR

Mix French Ultramarine Blue and Burnt Sienna into a nice gray. Then, while the surface still glistens, apply color to the top and bottom corners of one side of the paper with a no. 10 sable/synthetic blend round. Allow the color to blend out and soften into the clean water. These areas will become the sky and the reflection in the water. If necessary, use a damp no. 30 natural-hair round to blend the edges to prevent feathering.

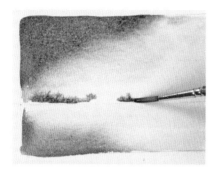
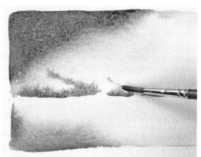

3 ADD THE LANDSCAPE

Using a no. 6 sable/synthetic blend round, mix Permanent Sap Green with Burnt Sienna. While the surface still has a dull sheen, apply color just above the dry paper area along the shoreline. Place diagonal brushstrokes of color to create the hills and trees. Avoid strokes that are too vertical or ridged. Try to create a softer, more natural ridgeline. Use the wet-into-wet technique to start giving definition to the composition. Once dry, apply a wet-into-dry application to start bringing out more definition and the impression of trees with a combination of hard and soft edges. Let dry.

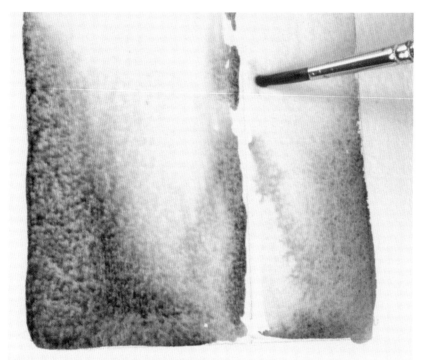

4 DEVELOP THE REFLECTION

Turn the paper vertically, then repeat the color application on the opposite side, creating a mirror image. Turning the paper makes it easier to see the reflection and helps you focus on the shapes instead of the image.

5 LAYER COLOR

Following the previous layer as a guide, layer color as needed. Let dry.

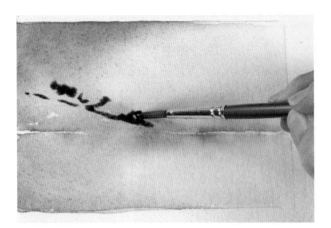 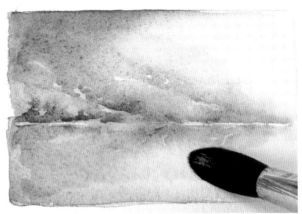

6 ADD THE DETAILS

Use nos. 6 and 10 sable/synthetic blend rounds to accentuate the hills, trees and shoreline with random brushstrokes on dry paper. Using a no. 30 natural-hair round, randomly soften some of the edges of the strokes to create a combination of hard and soft edges. This will allow you to create some details without overdoing it.

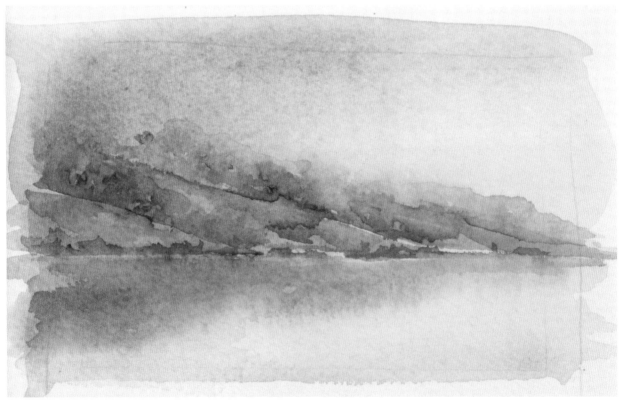

7 CONTINUE LAYERING

Add three to four additional layers as needed. There is no need to paint every detail—use your creative imagination to expand on what is really there. You can create wonderful magical paintings by simplifying the composition.

bolinas lagoon morning
watercolor on 300-lb. (640gsm) cold-pressed
paper | 5" × 7" (13cm × 18cm)

You can create dramatic paintings of early morning or evening skies with blended washes and minimal landscapes. The techniques in this demonstration work well for depicting several different atmospheric conditions.

MATERIALS

SURFACE
300-lb. (640gsm) cold-pressed paper (quarter sheet)

BRUSHES
no. 30 natural-hair round, nos. 14 and 20 sable/synthetic blend rounds, 2-inch (51mm) bamboo hake or a large wash brush

PIGMENTS
French Ultramarine Blue, Indigo, New Gamboge, Permanent Alizarin Crimson, Quinacridone Magenta

OTHER MATERIALS
pencil

TECHNIQUES
wet-into-wet (page 64)
layering (page 30)
blending (page 34)
hard and soft edges (page 35)

1 APPLY WATER
Create a simple pencil sketch. Then apply clean water over the entire sketch with a 2-inch (51mm) bamboo hake. Make sure the surface has sheen and that no one area is drier than the other.

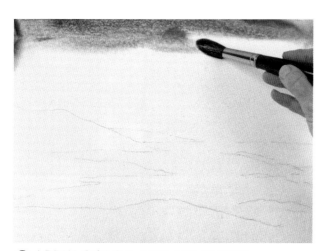

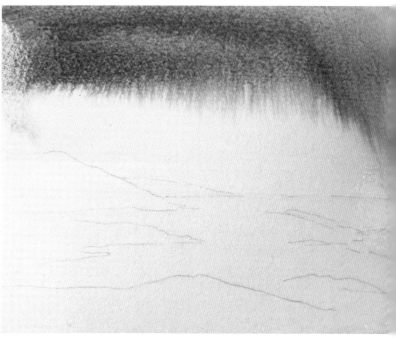

2 APPLY COLOR AND LET BLEND
Load a no. 30 natural-hair round with a mixture of French Ultramarine Blue and Quinacridone Magenta and apply color to the top of the paper, allowing it to blend out into the clean water.

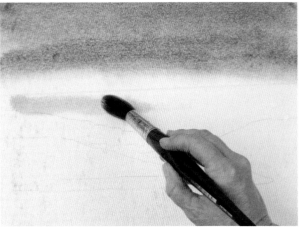

3 SWITCH AND BLEND COLORS

Make sure the surface is still wet enough to allow color movement, then switch to New Gamboge and Permanent Alizarin Crimson. Leave a 1-inch (25mm) space between colors. Lift and tilt the paper so that the colors can gently blend together without turning into mud.

4 BLEND THE COLORS

Continue applying the same colors with the addition of Quinacridone Magenta. Work to the bottom of the paper, then lift and tilt the paper to move and blend the color. This creates the foundation for the painting. If the color doesn't move, there isn't enough water.

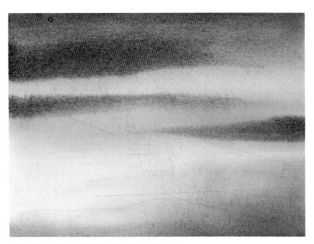

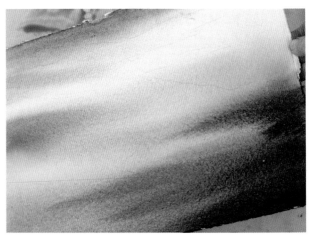

5 WORK WET-INTO-WET

While the surface is still damp, use a no. 20 sable/synthetic blend round to apply dark values and different hues of French Ultramarine Blue and Quinacridone Magenta to the sky. Let dry.

6 LIFT AND BLEND

To soften any feathering edges, lift and tilt the paper.

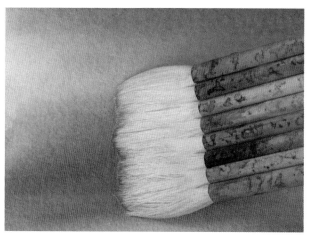

7 CONTINUE LAYERING

Color always dries lighter, so usually three or four layers are necessary to achieve the desired results. Using a bamboo hake, apply water over the entire surface. Then, using the previous layer as a guide, apply brushstrokes of color only where needed. Let dry.

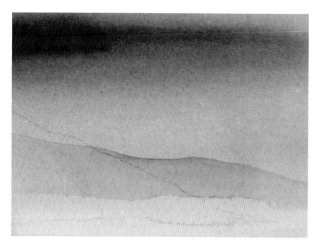

8 WORK WET-INTO-DRY

To apply color to a limited area, apply a brushstroke of color to dry paper, then use a bamboo hake or a no. 30 natural-hair round to soften the edges. You must move quickly or the color can dry, leaving unwanted lines.

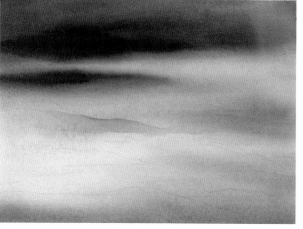

9 EXTEND THE LANDSCAPE

Once dry, use the palette mud (the leftover color in your palette) in a lighter value to further build the mountain range. Let dry.

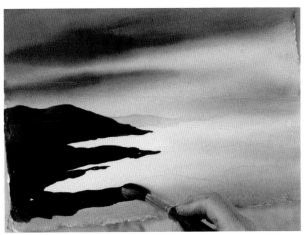

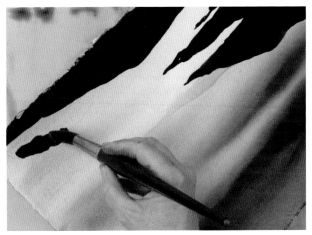

10 ADD THE FOREGROUND
Use a no. 14 sable/synthetic blend round for the details and a no. 20 round for the larger areas. Load the brush with a very dark value of Indigo, but make sure you have enough water so that the color moves easily without dragging. Apply the shoreline, but keep it simple.

11 TURN THE PAPER
Turn the paper upside down to create the shore rocks. Skip the tip of the brush across the tooth of the paper to create an uneven edge. This will only work if the paper is upside down. If the paper is right side up, there will be a more even line. (The tip of the brush creates a straighter line, while the heel creates a more uneven edge.) Let dry.

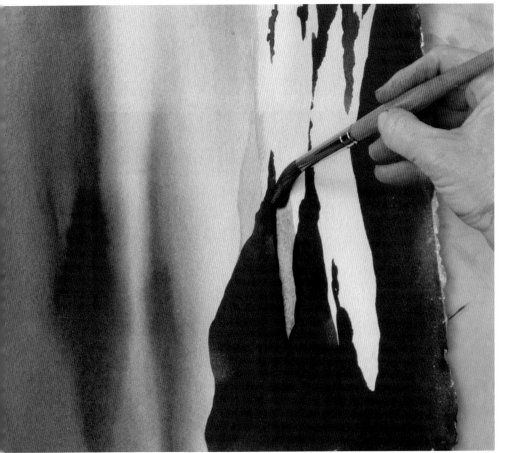

12 ADD THE REFLECTION
Turn the paper vertically. Use a light value of the Indigo rock color and a no. 20 sable/synthetic blend round to apply the mirror-image reflection of the rocks.

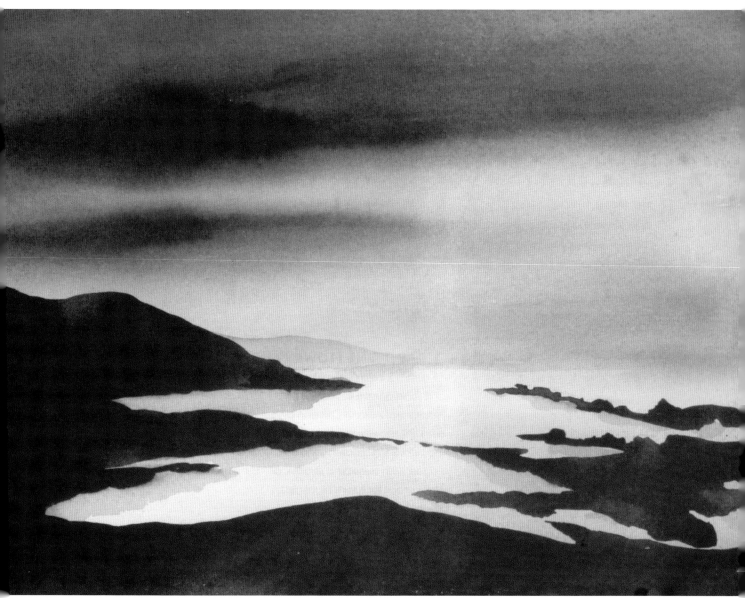

sunset on agate beach
watercolor on 300-lb. (640gsm) cold-pressed paper
22" × 30" (56cm × 76cm)

13 SIMPLIFY FOR THE BEST EFFECT

Less is usually best. Often landscapes don't need every detail. You don't have to paint every rock or blade of grass to be effective. Give the painting atmosphere with color and contrast. Create a story and give it feeling.

BLEND COLOR INTO THE SUBJECT

MATERIALS

SURFACE

300-lb. (640gsm) cold-pressed paper (half sheet)

BRUSHES

2-inch (51mm) bamboo hake or a large wash brush, nos.14, 20 sable/ synthetic blend rounds, no. 30 natural-hair round

PIGMENTS

Burnt Umber, Cyanine Blue, French Ultramarine Blue, Naples Yellow, New Gamboge, Permanent Alizarin Crimson, Quinacridone Magenta

Using the same blending techniques that we used in the sky of the land-scape in the previous demonsration produces entirely different results when applied to the main subject of the painting.

TECHNIQUES

- *wet-into-wet (page 64)*
- *blending and mixing color directly on the paper (page 34)*
- *hard and soft edges (page 35)*
- *layering (page 30)*
- *lifting (page 62)*
- *shadows (page 44)*
- *high contrast (page 45)*

1 PAINT ONE FLOWER AT A TIME

Use a 2-inch (51mm) bamboo hake or large wash brush to wet the largest and most dominant shapes one area at a time. Mix Naples Yellow with either Permanent Alizarin Crimson or Quinacridone Magenta for the petals. Use a no. 20 sable/synthetic blend round to add the color along the inside of the pencil line, allowing the color to blend into the clean water of the flower edges. With sweeping strokes, pull the color into the center. Leave enough white areas for future highlights. Do the same for each flower.

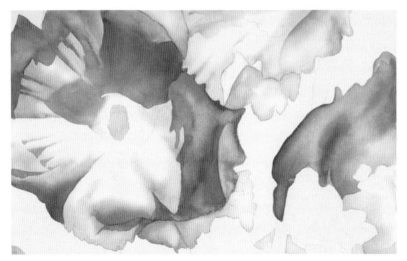

2 ADD SHADOWS

Add a little French Ultramarine Blue to the petal color mixture to create a cooler color for the shadow. If the color is too purplish in tint, add a little Burnt Umber to tone it down. Once every flower is filled with color, add the shad-ows in various values. Work in sections to prevent bleeding. Use clean water and a no. 30 natural-hair brush to soften edges. In some areas the color should gradually blend into the white of the paper to give the petal more shape.

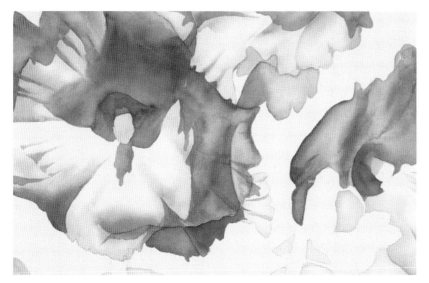

3 DEVELOP THE CENTER OF THE FLOWER

Mix Naples Yellow with a touch of the petal color to create a warmer yellow for the center stamen. Continue darkening the shadows where petals have the least amount of light.

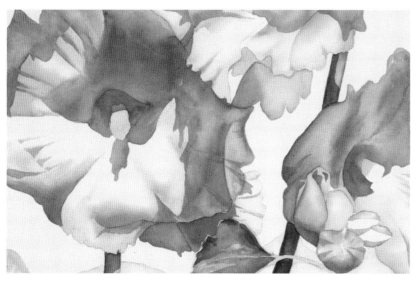

4 PAINT THE STEMS AND LEAVES

Mix New Gamboge with Cyanine Blue to create a fresh green. With the same technique that you used for the flowers in Step 1, use a no. 20 sable/synthetic blend round to fill the stems and leaves with water. Then apply color along the edges with a no. 14 sable/synthetic blend round, and allow the color to blend into the clean water.

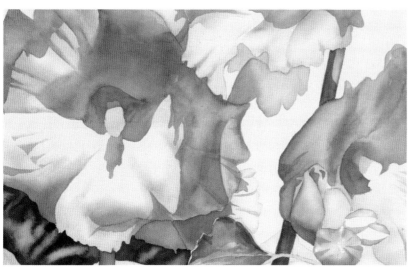

5 ADD MORE FOLIAGE

Using a no. 20 sable/synthetic blend round and the same leaf and stem color mixtures, fill in the background areas just under the petals. The dark contrast will push the flowers forward and make the painting pop. While the color is still damp, lift out a few areas with the brush to give the suggestion of more stems in the background.

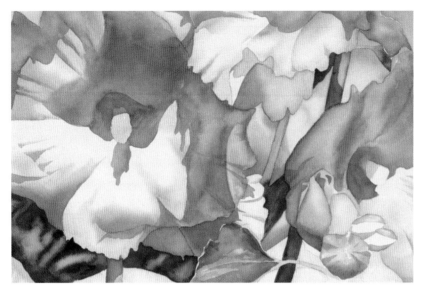

6 ADD THE BACKGROUND

Mix French Ultramarine Blue and Burnt Umber to create a soft blue-gray, then create the impression of sky. Using the wet-into-wet technique, apply some of the petal color to the background to create the impression of distant flowers. If left alone, the color can appear flat, so apply additional layers of color to create depth.

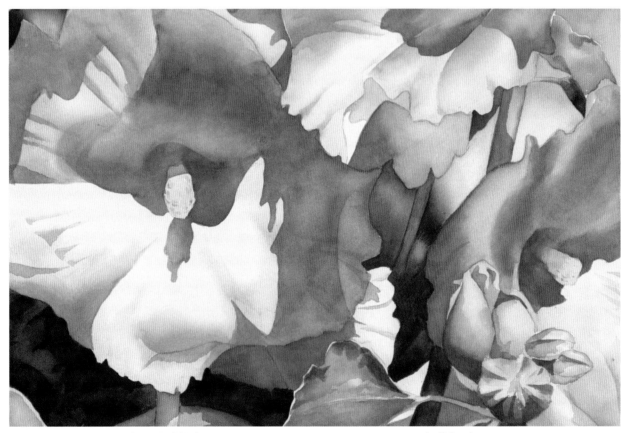

7 DEVELOP THE SHADOWS

Once the background is complete, revisit the shadows in the flowers. Consider incorporating more of the darker colors into the shadows to keep the painting balanced. Real flowers have more detail in the petals, which can be distracting if they're not painted correctly. There's no need to try to recreate a photograph. Capture the essence with simplicity.

hollyhocks
watercolor on 300-lb. (640gsm) cold-pressed
paper | 15" × 22" (38cm × 56cm)

As the white matilija poppy unfolds, the petals look like crumpled paper (this large flower almost resembles a fried egg). Painting these paperlike petals may look difficult, but just remember to simplify. Focus on what is important and don't sweat the small stuff.

MATERIALS

SURFACE
300-lb. (640gsm) cold-pressed paper (half sheet)

BRUSHES
no. 30 natural-hair round, nos. 8, 14, 20 sable/synthetic blend rounds, no. 8 synthetic round, 2-inch (51mm), bamboo hake or large wash brush

PIGMENTS
Burnt Sienna, Burnt Umber, French Ultramarine Blue, Indian Yellow, Indigo, Naples Yellow, Permanent Alizarin Crimson, Permanent Sap Green

1 BEGIN FORMING THE PETALS

Using a bamboo hake or large wash brush, apply water to each petal. There is usually enough color from the water bucket to tone down the stark white of the paper. With a no. 20 sable/synthetic blend round, apply a mixture of French Ultramarine Blue and Burnt Umber to create shading where needed.

Using a no. 8 or no. 14 sable/synthetic blend round and a mixture of French Ultramarine Blue and Burnt Umber or Burnt Sienna, apply the petal texture. Vary the brushstrokes from wide to small, focusing on the most dominant shapes. Soften some edges with clean water. The combination of hard and soft edges helps create texture.

TECHNIQUES
- *hard & soft edges (page 35)*
- *values & depth (page 47)*
- *shapes (pages 56, 58–59)*

2 FOCUS ON THE SHADOWS

Once the petals have color and texture, apply the shadows using the same color mixture in darker values. Apply water first and then color. Since the petals don't have much color, the shadows help to define their shape. Remember the different values in the shadows help push the image forward and prevent the image from looking flat.

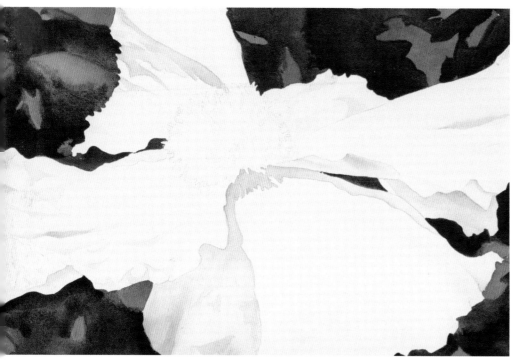

3 DEVELOP THE BACKGROUND

Working one area at a time, create abstract shapes with the following combinations: Permanent Sap Green and Indian Yellow, Permanent Sap Green and French Ultramarine Blue, Indigo and Permanent Sap Green, and Permanent Sap Green and Burnt Sienna. The shapes should resemble stems and leaves without much detail. Use a dark mixture of Permanent Sap Green and Indigo to soften the edges of the shapes. The combination of colors contrasts with the flower's edges and gives the impression of depth.

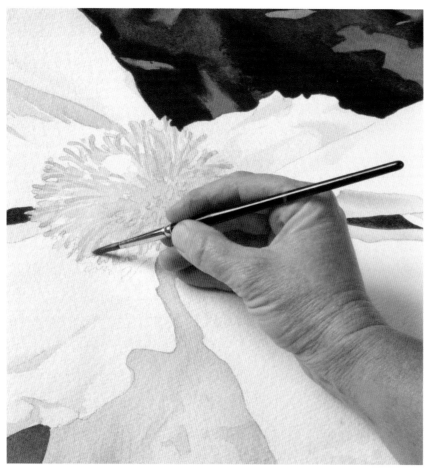

4 FORM THE CENTER

Mix Naples Yellow and Indian Yellow for the pistil and stamens in the center. Using a no. 8 synthetic round, start forming the center of the flower. Use irregular brush-strokes on the outside edges so that the center doesn't look like a ball. Leave some white "windows" in the center to show the petals underneath.

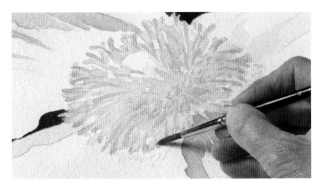

5 DEVELOP THE NEGATIVE SPACE IN THE CENTER

Use a no. 8 synthetic round to pull multiple stamens out of the negative space. Use different values of the same color mixture, or change the hue slightly by adding Permanent Alizarin Crimson to the yellow mixture and randomly apply color. Remember that you want to give the *suggestion* of detail. Don't overdo it.

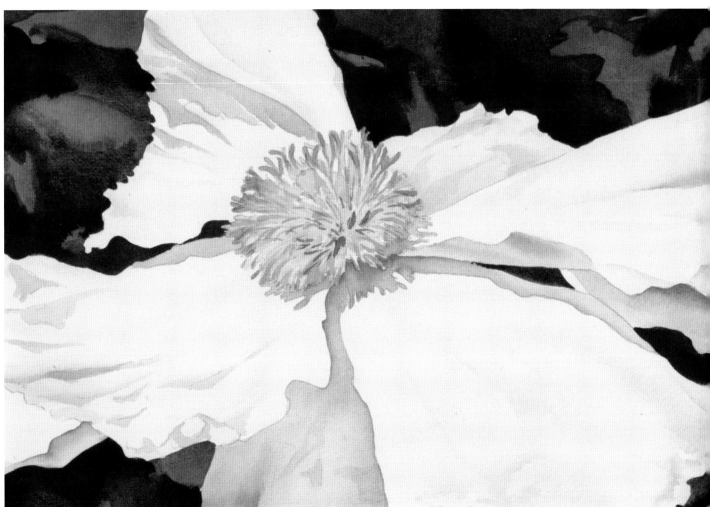

6 REEVALUATE AND ADD FINISHING TOUCHES

Reevaluate which areas need to come forward and which should be pushed back. If the background competes with the flower, apply a light Indigo wash to dull it down. This will make the white of the flower appear whiter and brighter and will simplify the composition. Darken the shadows of the flower where needed with darker shadow values. The combination of different values helps lift the petals and gives the flower more shape.

white matilija poppy
watercolor on 300-lb. (640gsm) cold-pressed
paper | 15" × 22" (38cm × 56cm)

BIG, BOLD, BEAUTIFUL SHADOWS

MATERIALS

SURFACE

30" × 22" (76cm × 56cm) 300-lb. (640gsm) cold-pressed paper (full sheet)

BRUSHES

no. 30 natural-hair round, nos. 20 sable/ synthetic blend round, no. 16 synthetic round (optional), 2"–3" (51mm–76mm) bamboo hake or wash brush

PIGMENTS

Carbazole Violet (or Winsor Violet), Indian Yellow, Indigo, Permanent Alizarin Crimson, Quinacridone Magenta, Winsor Red

Shadows add more intensity and drama to paintings. The values and their placement create excitement. (Darker colors push lighter ones forward.) Shadows can dramatically transform a painting.

1 PAINT ONE PETAL AT A TIME

Using a large bamboo hake or wash brush, apply water to one petal at a time. Load a no. 20 sable/ synthetic blend round with Winsor Red, Permanent Alizarin Crimson and Quinacridone Magenta. Apply color to the edges of the petal and pull the brushstrokes into the center, allowing the colors to mix and blend directly on the paper. While each petal is still wet, apply Indian Yellow and allow it to blend and transition into the red mixture.

TECHNIQUES

- wet-into-wet (page 64)
- blending and mixing color directly on the paper (page 34)
- hard and soft edges (page 35)
- layering (page 30)
- shadows (page 44)

2 APPLY SWEEPING STROKES

While the each petal is still damp, load a no. 20 synthetic or sable/synthetic blend round with blends of Permanent Alizarin Crimson and Quinacridone Magenta and apply swift sweeping strokes of darker values. The strokes should start at the outside of the petals and go inward. Lift and move the paper to soften the edges and prevent unwanted feathering. The dampness of the surface and the movement of the paper will affect how well you are able to do this.

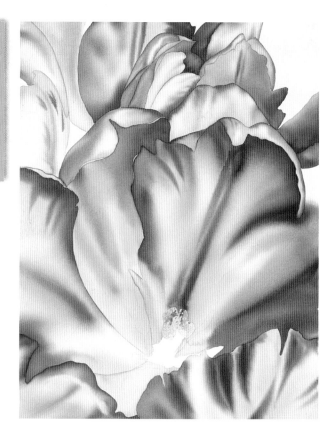

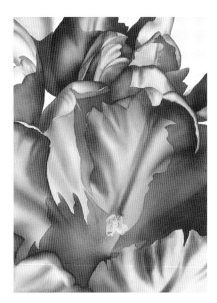

3 ADD THE SHADOWS

Add Carbazole Violet or a small amount of Indigo to the petal mixture. Starting with the largest shapes, add the shadows using a no. 20 sable/synthetic blend round. Apply water first with a bamboo hake or no. 30 natural-hair round, then color.

4 DEVELOP THE BACKGROUND

To create drama in this delicate flower painting, apply three to four layers of Indigo or other dark color mixtures in the background. When the background is complete, reevaluate the flower and deepen the shadows if necessary with darker values of the shadow color. For a less intense and dramatic painting, use lighter colors.

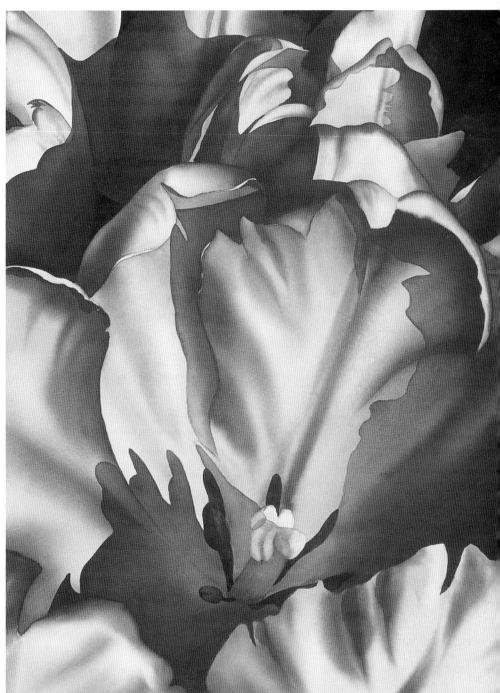

parrot tulips
watercolor on 300-lb. (640gsm) cold-pressed paper | 30" × 22" (76cm × 56cm)

INDEX

The best in fine art instruction and inspiration is from North Light books!

Chinese Watercolor Techniques for Exquisite Flowers
by Lian Quan Zhen

Through a number of step-by-step demonstrations, you'll learn how to paint flowers using a variety of techniques, including Chinese spontaneous style, Chinese detail style and traditional Western watercolor style. In addition, the author provides creative twists, including printing with glass, wrinkling rice paper, using a glue resist, blowing color and painting on primed canvas. The flowers portrayed in the book are favorites among watercolor painters and many are painted in two styles to provide a variety of options.

ISBN-13: 978-1-60061-088-2 | ISBN-10: 1-60061-088-9 | hardcover | 128 pages | #Z1977

Exploring Textures in Watercolor: A Hands-On Approach
by Joye Moon

Exploring Textures in Watercolor offers a combination of examples, mini-demonstrations and full step-by-step demonstrations showing ways to master the concepts of value, color, negative space and texture. A full range of techniques is explored, including pouring, masking, splatter, stippling, resist, collage, scraping and more. These basic skills and techniques are then incorporated into full-length demonstrations, and bonus inspirational sidebars provide you with ways to add texture to your life.

ISBN-13: 978-1-60061-028-8 | ISBN-10: 1-60061-028-5
hardcover with concealed spiral | 144 pages | #Z1315

The Painterly Approach
by Bob Rohm

Discover what the painterly approach is and how to define an object by planes of color and value rather than by line. Focus on abstract patterns rather than actual objects, on relationships between shapes rather than on detail, and on provoking an emotional response rather than absolute realism. Then move on to more advanced theories of brushstrokes, edges, form and shadows. Finally, a step-by-step approach to painting using alla prima and en plein air demonstration, will show you how to apply the painterly approach from start to finish.

ISBN-13: 978-1-58180-998-5 | ISBN-10: 1-58180-998-0 | hardcover | 144 pages | #Z0984

THESE BOOKS AND OTHER FINE NORTH LIGHT TITLES ARE AVAILABLE AT YOUR LOCAL FINE ART RETAILER OR BOOKSTORE OR FROM ONLINE SUPPLIERS. ALSO VISIT OUR WEBSITE AT **WWW.ARTISTSNETWORK.COM**.